M000092968

A BRIEF HISTORY *of*

SMYRNA
❖ GEORGIA ❖

A BRIEF HISTORY *of*
SMYRNA
✳ GEORGIA ✳

WILLIAM P. MARCHIONE, PhD

9-11-13

To Louisa —

 With great appreciation
for all your help.

 Bill Marchione

Charleston · London
THE
History
PRESS

Published by The History Press
Charleston, SC 29403
www.historypress.net

Copyright © 2013 by William P. Marchione, PhD
All rights reserved

Cover image: Front top courtesy of Dennis Tudor.

First published 2013

Manufactured in the United States

ISBN 978.1.60949.952.5

Library of Congress CIP data applied for.

Notice: The information in this book is true and complete to the best of our knowledge. It is offered without guarantee on the part of the author or The History Press. The author and The History Press disclaim all liability in connection with the use of this book.

All rights reserved. No part of this book may be reproduced or transmitted in any form whatsoever without prior written permission from the publisher except in the case of brief quotations embodied in critical articles and reviews.

I dedicate this book to my grandson, Samuel Alexei Glowaski, age three, who has the great good fortune to be growing up in Smyrna, Georgia.

CONTENTS

PREFACE

Wherever I have lived, even for relatively short periods of time, I have felt an irresistible temptation to delve into local history. Thus, after retiring to Smyrna, Georgia, from Boston in 2009, my attention was almost immediately drawn to the history of this interesting North Georgia community.

One major problem that confronts the historian studying Smyrna is a dearth of public records. None whatsoever exist for the first half century after the town's 1872 incorporation. Even in later decades, huge chronological gaps exist to challenge the historian.

The traditional explanation for this historical void—that a fire must have consumed Smyrna's town hall in the early 1920s—simply does not hold up. It isn't even clear that this small town, operating on a miniscule budget, had a town hall in the early 1920s. Moreover, there is nothing in the Marietta or Atlanta papers of the day to corroborate this story. Surely if a fire of such magnitude had occurred, these newspapers would have taken note of the event. I am forced to conclude that the void in Smyrna's town records was caused by careless recordkeeping and record management on the part of Smyrna's early town officials rather than a destructive fire. To make research into Smyrna's early history more difficult still, no local newspaper existed here to report day-to-day goings-on until well into the second half of the twentieth century.

I sought to offset the absence of public records and detailed newspaper coverage, to some degree at least, by means of careful, comparative analysis of available federal census schedules, an approach that yielded many valuable insights into the town's developmental history.

This book, it should be noted, gives considerable attention to the topic of race relations, an aspect of the town's history that earlier accounts have tended to ignore or romanticize. In pursuing this topic vigorously, I was mindful of what Stan Deaton, senior historian at the Georgia Historical Society, wrote in a December 29, 2012 *Atlanta Journal-Constitution* guest column. "History with boundaries cheats us all," Deaton admonished.

A host of friends and neighbors provided valuable assistance in the preparation of this history. I wish to acknowledge, in particular, the help and encouragement I received from Michael Terry, the historian of the Taylor-Brawner House and Brawner Hospital, and the author of the recently published book *A Simpler Time* (2012). Mike, who has deep roots in Smyrna, not only encouraged me to write about the history of his hometown but also placed several albums of historical material at my disposal.

Pete and Lillie Wood were also extremely helpful and supportive. They allowed me to borrow material they had gathered while working on Pete's memoir of Smyrna in the 1940s and 1950s, *The Paper Boy* (2006), a work based not only on his personal recollections of growing up in the town but also on a plethora of oral interviews that he and Lillie had conducted with hundreds of longtime Smyrna residents.

Helen and Nancy McGee, mother and daughter, allowed me not only to interview them but also to borrow a wonderfully informative set of diaries that Helen's mother, Bess Terrell, a Nebraska native newly come to Smyrna, kept between 1927 and the early 1940s.

Smyrna's longtime mayor, Max Bacon, graciously loaned me valuable historical documents that were in his keeping, along with photographs and scrapbooks relating to his own and his father Arthur Bacon's eventful mayoral terms, which together encompassed the last thirty-five years of the town's history.

Thanks also to Cecil Haralson, another resident with deep roots in Smyrna, who placed a cache of family documents at my disposal, and to Wayne Waldrip, who brought Cecil's collection to my attention and vouched for my reliability.

I am grateful to my neighbor and friend Andrea Searles for her assistance in researching Smyrna's predominantly African American Davenport Town/Rose Garden Hills neighborhood.

A major part of my research on Smyrna's history, it should be noted, was undertaken early on under the auspices of the Williams Park Neighbors, one of Smyrna's most active neighborhood associations, when I served as chair of its Local History Committee. I thank my neighbors in Williams Park for their generous support and encouragement of my research.

I wish also to thank the many other individuals who shared their knowledge of local history with me in countless taped interviews and casual conversations. These include Joe Bland, Kathy Brooke, Tom Camp, Casey Clavin, Roberta Cook, Ron and Liz Davis, Annie Dukes, Reverend James Hearst, Madge Jackson, Vic Koch, Leon McElveen, Kara Oden-Hunter, Nancy Smith and former town officials Harold Smith, Forster Puffe and Hugh Ragan.

For proofreading various chapters and providing useful feedback, I thank Mike Terry; Zack Berman; Forster Puffe; my wife, Mary Ann Marchione; Smyrna Historical and Genealogical Society curator Kara Oden-Hunter; and especially our good friend and neighbor Louisa Cohn, a professional proofreader in her earlier career, who gave the entire manuscript the benefit of a thorough read, in the process eliminating not a few inconsistencies of form.

Finally, I thank my daughter and son-in-law, Karen and Sean Glowaski, and my son, David Marchione, for the technical assistance they provided this often-perplexed elder citizen who is unlikely to ever fully master the complexities of digital technology.

THE NATIVE PEOPLE AND THEIR EXPULSION

The most sophisticated native civilization to arise in what is now the United States did so along the eastern bank of the Mississippi River and its many tributaries in the period of AD 800 to AD 1500. This so-called Mississippian Culture was marked by an impressive and complex urban lifestyle that included reliance on the rich agriculture of the surrounding alluvial plains, a vigorous trade and the erection of giant ceremonial mounds. The largest of the many Mississippian cities, Cahokia, situated across the Mississippi River from modern-day St. Louis, Missouri, contained at its height as many as forty thousand residents, making it as large, or larger, than any European city of its day.

Another Mississippian population center, at the opposite end of the Mississippian area in Etowah, although much smaller than Cahokia, lay in present-day North Georgia, a mere fifty miles north of the site where Smyrna would afterward be founded. The impressive Etowah mounds provide local evidence of the complexity and sophistication of this advanced native society.

The Mississippian culture went into decline in the fifteenth century for reasons that are not altogether clear. Its decline accelerated when Spanish conquistadors arrived on the west coast of Florida on May 30, 1539, with ten ships and more than six hundred soldiers, priests and adventurers. Hernando de Soto spent the next four years exploring the southeastern region for gold and silver, in the process brutalizing and decimating the native population. He died during these explorations and was buried, rather fittingly, on the

banks of the Mississippi River, a body of water he had "discovered" and claimed for the Spanish Crown in May 1541.

With the arrival of the first white explorers also came diseases to which the natives had no immunities. Of these, smallpox was the most virulent. It is estimated that the population of the Muscogee Creeks, the descendants of the Mississippian people who occupied Georgia and vicinity, was reduced by 90 percent by these outbreaks of epidemic disease.

Although much reduced in numbers, the Muscogee people continued to dominate the general area for the next two centuries, only to eventually be driven across the Chattahoochee River by another powerful native people, the Cherokees, who had emerged from the southern Appalachian Highlands. The Cherokees, by degrees, came to dominate a vast area of some 100,000 square miles that by the year 1700 included most of the present-day Kentucky, the eastern two-thirds of Tennessee, southwestern Virginia, western North Carolina, northern Alabama and the portion of Georgia lying northwest of the Chattahoochee River.

Generally speaking, Cherokee relations with their neighbors, native and white alike, proved contentious. The Cherokees were a numerous, powerful, enterprising and warlike people. Regular contact with Europeans had begun in the mid-seventeenth century when English traders from Virginia began moving into the area. The Cherokees at first welcomed these incursions, which provided opportunities for trade and the acquisition of manufactured goods.

However, this initial period of relatively peaceful relations ended abruptly in the mid-eighteenth century when war broke out between the Cherokees and land-hungry white settlers converging on their territory from the east, chiefly Carolinians. Then, during the period of the American Revolution, the Cherokees sought to hold back these interlopers by allying themselves to the British Crown, thus engaging in bloody warfare with the frontier whites. These wars, which continued for the next half century, also involved warfare with other Indian peoples, chiefly their traditional rivals, the Creeks.

The cession of Cherokee land to white settlers was a recurrent aspect of the relationship between the Cherokee nation, its various chieftains and the white political entities of the day—neighboring colonial governments, the British Crown, the U.S. government and the various states that sought title to Cherokee territory on behalf of their land-hungry residents. Sizeable acts of cession were made in 1721, 1755, 1768, 1772, 1773, 1775, 1777, 1783, 1785 and 1798. This resulted in a drastic reduction in the size of the Cherokee nation by 1820 to less than one-third of the extensive domain the tribe had controlled one hundred years earlier. Also, significantly, by 1800, fully half

of what was left of the diminished Cherokee domain lay within the boundaries of the present-day state of Georgia.

Not much is known about the native towns that existed in the area where Smyrna was later founded, but there were apparently several, although their size is hard to estimate. An important Creek town, Standing Peachtree, was situated just two miles southeast of the point where the main north–south highway of the day (a native pathway corresponding to present-day Atlanta Road) reached the Chattahoochee River. This strategically important native community extended along both sides of Peachtree Creek. Standing Peachtree was a major contact point for both Indian and white traders in the early nineteenth century. During the War of 1812, a fort was built at Standing Peachtree by the State of Georgia to protect the area from the warring natives.

While no sizable native communities existed in the immediate vicinity of Smyrna, the possibility of finding native archaeological remains in the area is nonetheless high, for the native peoples utilized the area in myriad ways over the centuries. One such archaeological discovery, for example, was recently made along Nickajack Creek at the western edge of Smyrna.

CHEROKEE CHIEF JAMES VANN, 1766–1809

The extent of Cherokee intermarriage with whites and the adoption by the Cherokee leadership of the social and economic practices of white society were powerfully reflected in the career of Cherokee chieftain James Vann. He was the most important Cherokee leader who was a native of the Cherokee Lower Towns in Georgia and eventually became the richest man in the entire Cherokee nation. Vann was born in 1766, the son of a mixed-race Cherokee mother and a Scotch fur trader. In Cherokee society, children took their status from their mother's people. Thus, Vann grew up as a member of the Anigategawi or Wild Potato People Clan, but he was apparently also raised bilingually, learning the ways of white society from his father. Although Vann fought for the Cherokee in the brutal Chickamauga War (1776–96), he seems to have urged more humane policies upon his compatriots. Vann eventually emerged as one of a triumvirate of influential Cherokee leaders that included Major Ridge and Charles R. Hicks, the Cherokee leaders of the Upper Towns of East Tennessee and North Georgia.

Vann was a man of marked political and economic talent. He profited from negotiations with the U.S. government over a right-of-way for the Federal Road through the Cherokee nation to such an extent that by 1804 (at the age of thirty-eight), he was able to build an elaborate brick Federal-style mansion, Diamond Head, situated in what is now Chatsworth, Georgia, adjacent to the Federal Road, a

building that still stands and that enjoys the distinction of being the most elaborate residence built by a native leader in North Georgia. Here, Vann, who maintained a plantation of eight hundred acres and owned an estimated one hundred slaves, also opened a store and a tavern and operated a ferry on the nearby Conasauga River. In 1804, Vann established the first ferry across the Chattahoochee River where the road to the Lower Towns of the Creeks crossed the great river not far from present-day Atlanta. He also owned a trading post near Huntsville, Alabama.

The politics of the Cherokee nation continued to be both contentious and bloody in the years that followed. In February 1809, James Vann, then only forty-three years of age, was shot to death while riding patrol in North Georgia. The identity of his assassin has never been established. This important Cherokee leader was buried at or near Blackburn Cemetery in Forsyth County, Georgia.

At the onset of the nineteenth century, the nearest Cherokee settlements of any size were Buffalo Fish Town, Sweet Water Town and Nickajack Village. Buffalo Fish Town was located about sixteen miles southwest of Marietta, which would seem to place it in the vicinity of present-day Austell or neighboring Lithia Springs, Georgia. Notably, Lithia Springs was an important religious center for the native peoples. Sweet Water Town and Nickajack were both situated in present-day Mableton, Georgia, in the southern part of Cobb County.

During the War of 1812, the Creeks and the Cherokees took opposite sides. The Creeks allied with the British, while the Cherokees supported the U.S. government. In 1814, Andrew Jackson decisively defeated the Creek nation in the Battle of Horseshoe Bend with support from the Cherokees. This defeat forced the Creeks to cede a huge expanse of territory to the United States. It should be noted that the fate of the Cherokees closely paralleled that of the Creeks, with the process of displacement somewhat slower owing to the various treaties they had signed with the federal government. Federal authorities during the James Monroe and John Quincy Adams presidencies sought to honor these agreements. Despite the federal commitments, however, squatters continued to settle on land all over the Cherokee nation. A squatter could legalize his claim by marrying a Cherokee, so there was also an increase in marriages between whites and Cherokees in this period.

The Cherokees had in the meantime adopted many institutional mechanisms patterned after those of white society. The tribes of the Southeast are often referred to collectively as the "Five Civilized Tribes" owing to this tendency to adopt white practices—none more so than the

Cherokees. By the early 1800s, they had established businesses, farms, Christian churches and a government quite similar in structure to that of white society, including a Council (Congress) and a Supreme Court. They established a national capital in 1819 at "New Town" (renamed New Echota in 1825) situated about forty miles north of present-day Smyrna.

Especially notable was the official adoption by the Cherokees in 1825 of a syllabary, or alphabet—developed after twelve years of experimentation by a brilliant native intellectual named Sequoia—that provided them with a written language. This innovation effected a fundamental change in the character of Cherokee society.

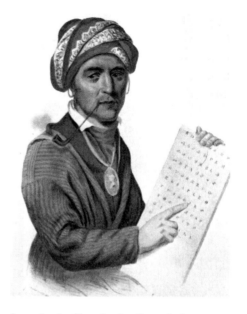

Sequoia, the Cherokee intellectual who developed the Cherokee alphabet or syllabary, the first Native American written language, which was officially adopted by the Cherokee nation in 1825.

By the early 1830s, an amazing 90 percent of the Cherokees, a previously illiterate people, had learned to read and write their native language. A national newspaper, the *Cherokee Phoenix*, was established by the Cherokee Council in 1826, and in 1827, a Cherokee national constitution was adopted.

Whites pushing west, whether as farmers or prospectors, not only coveted Cherokee land but also believed themselves entitled to take possession of it from a people most continued to regard as both racially inferior and inherently savage. The State of Georgia claimed absolute sovereignty over all land lying within its boundaries. Accordingly, the Georgia legislature declared the Cherokee tribal government at New Echota illegal. While the government in Washington had given a measure of support to Cherokee claims prior to 1829, with the coming into office in 1829 of President Andrew Jackson, the military hero who defeated the Creeks at Horseshoe Bend in 1814, the U.S. government also threw its authority behind a program of forced native displacement and removal.

The Cherokees resorted to the U.S. Supreme Court in 1831. They sought a federal injunction against laws passed by the State of Georgia depriving

them of rights within their tribal boundaries. However, the Supreme Court declined to hear the case, ruling that it had no original jurisdiction in the matter—the Cherokee were a dependent nation with a relationship to the United States like that of a ward to its guardian. Then, in another decision dating from 1832 and stemming from a suit brought by missionaries challenging state authority over their activities in the Cherokee nation, Chief Justice John Marshall, writing for the court's majority, declared the Cherokees to be a "distinct community…in which the laws of Georgia can have no force." However, the Jackson administration refused to accept this unwelcome decision.

Encroachment on Indian land was meanwhile greatly accelerated by the discovery of gold in North Georgia in 1828. Gold fever was now added to land hunger as an incentive to displace the Cherokees. The gold fields were largely concentrated in present-day Lumpkin, White, Union and Cherokee Counties, well north of the site of Smyrna. It is estimated that there were six thousand to ten thousand miners present in the area between the Chestatee and Etowah Rivers by 1831, leading to the rise of boomtowns like Dahlonega and Auraria.

The State of Georgia designated the entire northwest corner of the state, the area claimed by the Cherokee nation, as Cherokee County in December 26, 1831, thereby affirming jurisdiction over the area, and on December 3, 1832, it proceeded to subdivide that area into ten smaller counties, the most southerly of which it named for the late Thomas Willis Cobb (1784–1830), a much admired former Georgia congressman, U.S. senator and Georgia Superior Court judge who had recently died at the relatively young age of forty-six.

Two roads passed through the general vicinity at the time of Cobb County's creation, roadways that facilitated white migration: the old Alabama Road, originally an Indian path, which ran in an east–west direction from South Carolina through Georgia to Alabama, and a north–south roadway leading to a shallow ford on the Chattahoochee River, corresponding to present-day Atlanta Road.

This migration of whites into the area was facilitated by the establishment between 1820 and 1844 of three Chattahoochee River ferries that provided white settlers access to Cobb County, there being no bridges of any kind across that portion of the river before 1838. The first bridge across the Chattahoochee into South Cobb was built in 1838 to accommodate the Western & Atlantic Railroad, a turning point event that will be discussed in more detail in the next chapter.

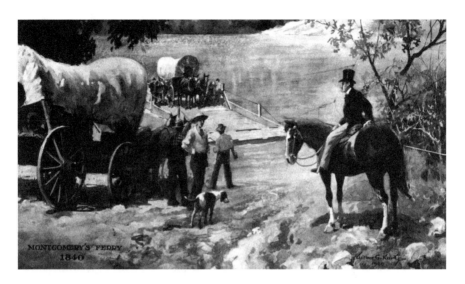

This illustration by artist Wilbur Kurtz depicts James McConnell Montgomery on horseback supervising the operation of his ferry on the Chattahoochee River, one of the several that conveyed pioneer settlers across that river into Cobb County in the early years. *Courtesy of Wilbur Kurtz III.*

These ferries were privately owned public utilities incorporated and regulated by the Georgia legislature to transport travelers and livestock across the river for a fee. They were highly profitable ventures that vigorously competed for available traffic. A typical fee schedule (this example established in the 1830s by the Montgomery Ferry) charged six cents per person, ten to twelve cents for a man and a horse and two to four cents for a farm animal.

The first ferry to service Cobb County was founded by farmer John B. Nelson in 1820. It emanated from the point on the southern shore of the Chattahoochee where Sandy Creek flows into the river, near the eastern end of what is now the Fulton County Airport. Nelson operated this ferry for only a brief period, from 1820 until 1825, when he is said to have been murdered, but his successors continued its operation into the 1840s. The Nelson Ferry was ultimately driven out of business by the more conveniently situated nearby Mayson-Turner Ferry.

The second ferry serving Cobb County was founded in the early 1830s by James McConnell Montgomery and was situated at the point where the main north–south roadway reached the Chattahoochee River.

James McConnell Montgomery resided near Standing Peachtree on the river's southern shore in what was then still DeKalb County. There he built a home for his wife, Nancy, and their thirteen children. Montgomery was

also a major political leader in DeKalb (the western part of Dekalb County was renamed Fulton County in 1853), serving at various times as a census taker, land assessor, county clerk, school commissioner, state senator and postmaster. He was also, by some accounts, the earliest settler in what would afterward become the community of Buckhead. Although Montgomery died in 1847, his ferry continued operating into the 1870s.

The third ferry serving Cobb County, the Mayson-Turner Ferry, was established in 1844 by James Mayson of DeKalb County and Daniel R. Turner of Cobb County. This ferry accessed Turner Ferry Road, a pathway corresponding to the present Bankhead Highway. It had the longest lifespan of the three ferries, surviving from 1844 to 1897, when it was replaced by a bridge.

Since the white population's demand for land greatly exceeded the available supply, the State of Georgia resorted in 1832 to a whites-only land lottery as a method of distribution (a technique the state had already employed on several occasions). Anticipating that gold might be found along all of the streams that emptied into the Chattahoochee River, the bulk of Cobb County's acreage was divided into 40-acre gold prospecting parcels rather than 160-acre farming parcels.

There were, in fact, three lotteries conducted in 1832–33—one for 160-acre farm lots, another for 40-acre gold lots and a third for undistributed or fractional parcels. To be eligible to receive a parcel, one had to be an adult white male, as well as a citizen of Georgia for a prescribed period of time. Indians were ineligible to participate, as were free blacks. Some persons, such as Revolutionary War veterans, widows and orphans, were allowed more than one draw.

Despite the high expectations with respect to gold deposits, no significant amounts of the precious metal were unearthed in Cobb County. The rich North Georgia gold fields, as previously noted, were situated forty to fifty miles to the north, in an area centered on Lumpkin County. However, the Georgia gold rush fostered Cobb County's development. The most important economic activity carried on in Cobb in the early 1830s was farming, with local farmers sometimes selling goods to prospectors bound for the gold fields. While difficulties with the Cherokees continued, Cobb was a safer haven for settlers than most points farther north. However, farming was not an especially lucrative activity, and most Cobb County farms were in this early period self-sufficient rather than commercial operations. Half a dozen years later, a major public works project—the Western & Atlantic Railroad—would offer a much greater stimulant to local growth.

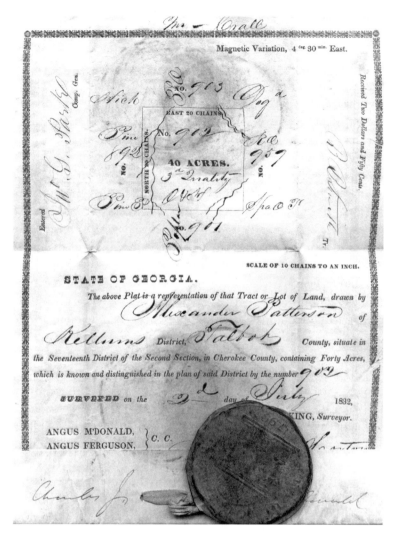

An 1832 Cherokee land lottery certificate issued to Alexander Patterson of Kellums District, Talbot County, Georgia. This forty-acre parcel was situated in present-day Vinings. Polo Lane passes through the center of this property. *Courtesy of Cecil Haralson.*

The drawings for land lots were conducted at the state capitol at Milledgeville. Tickets with the names of eligible applicants were placed in one drum or wheel, and numbered slips of paper for each lot were placed in another wheel, with lottery officials drawing one slip from each wheel to determine winners. The recipients were then required to pay a small service fee before being issued a deed.

Since not all Cobb County land lottery recipients actually settled on the acreage to which they had won title, but rather held on to the land for possible future resale (land speculation being endemic on the expanding American frontier), the lists of 1832–33 Cobb County land lot recipients are in themselves an uncertain guide to the identity of the settlers who actually established themselves in the vicinity of Smyrna. Cobb County historian Sarah Blackwell Temple devoted many pages of her thoroughly researched history *The First Hundred Years: A Short History of Cobb County Georgia* (1930) to identifying those who actually settled in Cobb, but she was unable to provide a definitive list. Temple attributed her inability to "the general destruction in 1864…of all but a handful of county documents and of most family records, adding that family lines traced by genealogists in recent years are of small help in determining when people came into the county." Thus we are thrown back on often confused and unreliable sources in trying to differentiate between original recipients of land grants and those who actually settled in the area afterward designated as Smyrna.

One indisputable indication of the presence of individuals in the area from an early date is the many church and family graveyards of South Cobb (i.e., the area south of modern-day Marietta, an area now largely in the orbit of Smyrna). When a name from the list of 1832–33 land lottery recipients also appears on a headstone of one of these cemeteries, we have pretty clear evidence that the individuals in question not only took possession of their allotments but also remained in the general area to the end of their lives. Another indication of the presence of a land lot recipient in Cobb County is the federal censuses of 1840, 1850 and 1860. These sources record that the most notable pioneer settlers of the South Cobb area were Hardy Pace, Asbury Hargrove, John Gann, Joseph Turner, Robert Daniell, Henry Gann and Thomas Hooper, each of whom sank deep roots in the area, attaining a degree of prominence in local economic and political life and founding families who resided in Smyrna and vicinity for generations.

The establishment of Smyrna as a distinct community began with the founding of the Concord Primitive Baptist Church under the leadership of Reverend Thornton Burke in 1832 in a log structure that also served as a schoolhouse; the building stood at or near the intersection of present-day Concord Road and South Cobb Drive. However, in 1833, this congregation moved south to the Mableton area, where it still exists as the Concord Baptist Church.

Far more significant as a point of origin of Smyrna was the establishment, at an uncertain point in the late 1830s or early 1840s (documentary

evidence of the precise date does not exist), of the Smyrna Campground by the area's Methodists. The campground served as a gathering point for religious services in a day when Methodist preachers rode circuit and made irregular visits owing to their limited number and the long distances they were obliged to travel in this sparsely settled district.

At the center of the Smyrna Campground, just south of present-day Market Village, a brush arbor was built in the late 1830s by local Methodists for religious services, marking the institutional beginnings of Smyrna.

The Smyrna Campground was laid out on a forty-acre parcel of land belonging to Wiley Flanigan of Campbell County, who did not himself move to Smyrna until 1843. As noted in the published history of the Smyrna United Methodist Church: "It is conceivable that the plot could have been used as a meeting place with or without the permission of anyone." This campground was situated on the south side of today's Market Village and is said to have been enclosed on the east by Atlanta Road, on the south by Concord Road, on the north by West Spring Street and on the west by Davis Street. Religious services were in the early years conducted under a brush arbor, described as "a crude temporary shelter of poles with brush roof, boards, and other available material."

In about 1846, a permanent church building was constructed at the campground site. The families of Asbury Hargrove, Hardy Pace, Pinckney H. Randall, Martin L. Ruff and William Bowie have been identified as the earliest congregants of this pioneer church.

The name given the campground, Smyrna, was biblical in origin. It was taken from the book of Revelations and was the name of one of Paul the Apostle's seven churches in Asia.

The relationship between the Cherokees and North Georgia's white settlers continued to deteriorate in these years, leading the U.S. government under President Martin Van Buren, Andrew Jackson's successor, to forcibly remove the Cherokees in 1838 from their tribal lands to the distant Indian Territory (present-day Oklahoma). The process of herding the natives into what were essentially concentration camps was marked by great severity.

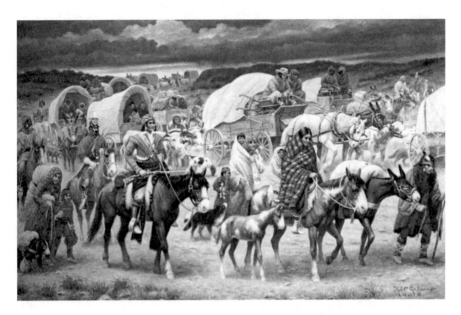

This illustration depicts the removal of eighteen thousand Cherokees from their ancestral lands in the eastern United States to the Indian Territory (present-day Oklahoma) in 1838. About one quarter of the Cherokee perished in this wintertime forced march, known to history as the "Trail of Tears."

The local Cherokees were escorted to Fort Bluffington in Canton, Georgia. One writer, quoted in Temple's *First Hundred Years*, left the following detailed description of this roundup of the native population that powerfully testifies to the harshness of the removal process:

> *Under* [General Winfield] *Scott's orders the troops were disposed at various points throughout the Cherokee country, where stockade forts were erected for gathering in and holding the Indians preparatory to removal. From these squads of troops were sent to search out with rifle and bayonet every small cabin hidden away in the coves or by the sides of mountain streams to seize and bring in as prisoners all of the occupants, however or wherever they might be found. Families at dinner were startled by the sudden gleam of bayonets in the doorway and rose up to be driven with blows and oaths along the weary miles of trail that led to the stockade. Men were seized in their fields or going along the road, women were taken from their wheels and children from their play. In many cases in turning for one last look as they crossed the ridge, they saw their homes in flames, fired by the lawless rabble that followed on the heels of the soldiers to loot*

and pillage. So keen were these outlaws on the scent, that in some instances they were driving off the cattle and other stock of the Indians almost before the soldiers had fairly started their owners in the other direction. Systematic hunts were made by the same men for Indian graves, to rob them of the silver pendants and other valuables deposited with the dead. A Georgia volunteer, afterward a colonel in the Confederate service, said: "I fought through the Civil War and have seen men shot to pieces and slaughtered by the thousands, but the Cherokee removal was the cruelest work I ever saw."

Of the nearly eighteen thousand Cherokees who began the one-thousand-mile, 116-day trek under army escort, fully four thousand perished along the way from illness, cold, starvation and exhaustion. The U.S. Army forced a continuous pace at rifle and bayonet point in this wintertime removal, with scant regard to the terrible hardship suffered by these beleaguered travelers. For this reason, this journey is known to history as the "Trail of Tears."

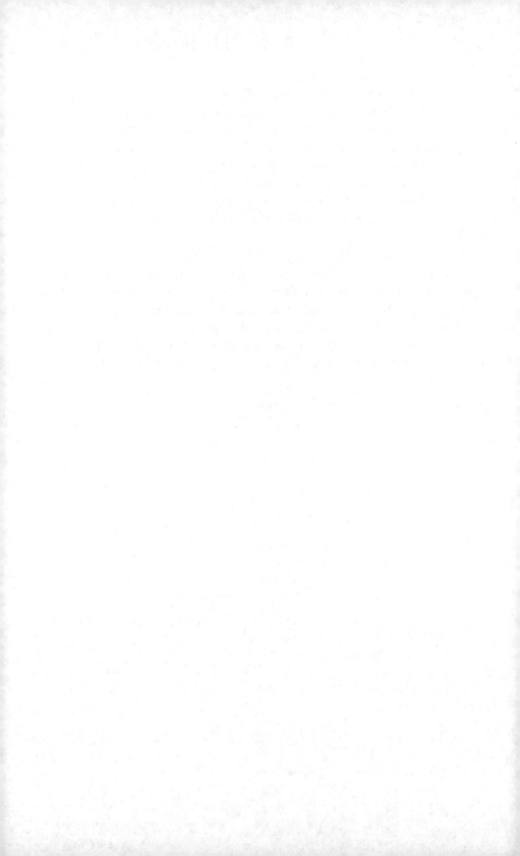

LAYING SOUTH COBB'S FOUNDATIONS, 1825–1860

S myrna did not emerge as a distinct political entity until 1872, and at its inception, it had limited boundaries. The focus in this discussion of the area's early history will therefore be on the southern part of Cobb County as a whole rather than the shifting political entity of Smyrna.

While most of the residents of the southernmost part of Cobb County identified themselves as farmers, the topography and climate of the area did not provide ideal conditions for commercial agriculture. Unlike middle and southern Georgia, where "cotton was king" the farms of Cobb County produced relatively little of that commodity, and cotton plantations in the sense of large units worked by slave labor were a rarity. The farms of South Cobb were mostly small-scale, family-run units—subsistence farms producing food mostly for local consumption that placed scant reliance on slave labor. This is not meant to suggest that slavery did not exist in South Cobb in the early years, only that slavery was a good deal less important locally than in more southerly sections of Georgia. As late as 1860, Cobb County's slaves formed a mere 15 percent of the area's total population, as compared to 44 percent for the state as a whole, as well as an even higher 55 to 59 percent in Georgia's principal cotton producing areas.

It should also be emphasized that the handful of local men who accumulated significant wealth in the antebellum period did so not primarily as farmers but rather through commercial and manufacturing ventures. Before the Civil War, there were no fewer than twenty-three gristmills in the general area, some five sawmills and one large-scale textile mill, and these manufacturing

Founded in the 1840s by William Daniel and subsequently owned by the Ruff family, Ruff's Mill was one of twenty-six early water-powered mills in South Cobb and stood on Nickajack Creek several miles west of the Smyrna Campground. The building still stands today.

establishments, driven by the ample water supply available in the area, generated far more wealth for their owners than did agriculture.

The richest single resident of South Cobb—or the Lemons District, as the area was designated in early federal censuses—was Hardy Pace, the founder of Vinings. Pace's career offers an excellent example of how the area's entrepreneurial element accumulated significant wealth in the early years. The founder of Vinings acquired the bulk of his wealth from nonagricultural ventures—operating a gristmill, ferrying passengers across the Chattahoochee and hiring out his slaves to work on public works projects.

Pace had taken advantage of a 1777 act of the Georgia legislature that awarded generous land grants to anyone who established a gristmill or lumber mill. As one recent commentator noted of this enterprising pioneer: "Given Pace's propensity for economic opportunity and accumulation of property, owning and operating a mill [was] an appropriate acquisition, and [Pace] likely began operation of [his grist mill] in the late 1830's or

early 1840's [acquiring] some 100 acres in the process." Moreover, Pace was associated in this milling enterprise with another wealthy local entrepreneur, Pinckney H. Randall, who by 1860 was living across the Chattahoochee River in DeKalb (now Fulton) County but nonetheless played an important role in the early economic development of the South Cobb area. Randall, for example, helped found the Smyrna Methodist Church.

Hardy Pace was also the largest slave owner in antebellum South Cobb but apparently employed few of his chattel on the land. There was far more money to be made, he recognized, by hiring out his slaves to work on the area's developing road system and the construction of the all-important Western & Atlantic Railroad. While this singular entrepreneur doubtless engaged in some farming—marketing the crops he raised in Marietta, Atlanta and other nearby population centers—farming would seem to have been the least important and least profitable of his various economic activities. The 1860 Federal Census estimated Pace's wealth at $41,500, the equivalent of millions of dollars today, while it estimated the wealth of his sometime business associate Pinckney Randall at $25,000, also a substantial fortune.

A similar pattern is evident in the careers of other South Cobb entrepreneurs. Robert Daniell (1818–1881) began his successful career as a local manufacturer by first acquiring a share of a gristmill on Nickajack Creek. Then, in 1847, with his partner in that milling enterprise, Martin L. Ruff (1805–1877), he cofounded the Concord Woolen Textile Mill a few miles west of the Smyrna Campground, where a complete mill community, called Mill Grove, soon sprang up.

The Concord Woolen Mill, which suffered through many vicissitudes, including destruction by Sherman's invading Union army in 1864, was rebuilt shortly after the war on an even more substantial basis and survived under various owners into the early twentieth century. It was the largest manufactory in the general area. The commercial vitality of the developing Mill Grove community is evidenced by the establishment there in 1849 of South Cobb's first post office. By 1860, the wealth of Robert Daniell, estimated at $37,400, stood second only to that of Hardy Pace in South Cobb, while that of his business associate Martin L. Ruff stood at a somewhat lower though not unsubstantial $13,000.

Another local entrepreneur, Leonard Dodgen (1812–1875), established a gristmill on Nickajack Creek and followed a similar path to prosperity. Dodgen's wealth in 1860 was an impressive $19,960.

By 1860, South Cobb was dotted with lucrative small-scale milling establishments, located chiefly along Nickajack and Rottenwood Creeks,

George Foster Pierce, 1811–1884

George Foster Pierce was born on February 3, 1811, in Greene County, Georgia, into a family of distinguished Methodist preachers. The published history of the Smyrna United Methodist Church tells us that this leading religious figure, who later served as president of Emory College and as a Methodist bishop, "often preached in both the original Smyrna brush arbor and in the log Methodist church building constructed in 1846 on the Smyrna Campground."

Pierce was converted to the Christian faith at the age of sixteen in a revival at Franklin College (as the University of Georgia was originally known), from which he subsequently graduated. In 1831, at the age of twenty, he joined the Traveling Ministry of the Methodist Episcopal Church and rode circuit for the next several years.

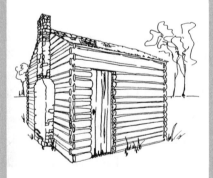

In 1846, the Methodists built a log church on the Smyrna Campground. Destroyed during the Civil War, it was soon after replaced by a small wood-frame building, which served the congregation until the building of a more ample edifice in 1882.

the principal tributaries of the Chattahoochee River in Cobb County. These early entrepreneurs recognized that harnessing the area's waterpower to process and manufacture goods was a far more certain road to prosperity than farming.

Before the area could reach its fullest potential, however, its serious transportation deficiencies would have to be addressed. In the early years, the main north–south highway in Cobb County (present-day Atlanta Road) was the area's principal link to the outside world, but transporting people and goods along that still primitive roadway was slow, unreliable and uneconomical. This was especially the case during periods of heavy rain, when horse-drawn conveyances could get bogged down in a morass of mud.

It was not only the area's farmers and manufacturers who were inconvenienced by South Cobb's primitive transportation system but also the congregants of the local Methodist and Baptist churches, who were dependent on a circuit riding itinerant ministry for irregular religious services.

The earliest church founded in the area and the very first church established in Cobb County, as already noted, dates back to the fall of 1832. Its original log meetinghouse stood near the

present-day intersection of Concord Road and South Cobb Drive on the site now occupied by the Crossings Shopping Center. However, within a year, the congregation had moved some distance west to accommodate the residents of the Mill Grove community then developing around Ruff's Mill. The historic Concord Baptist Church still exists and is today situated where Concord Road dead-ends just over the boundary in Mableton.

The most distinguished by far of the itinerant ministers who came into the area in the early years was Reverend George Foster Pierce, a leading force in the religious and educational history of the state.

Ironically, the great river that runs along the southeastern edge of Cobb County, the Chattahoochee, contributed little to the resolution of the area's transportation problems. The section of the Chattahoochee that skirts Cobb is full of impediments to navigation, chiefly rocks and sandbars. The river thus provided no natural highway to facilitate the movement of people and goods into the northern section of the state. While attempts were made to transform the Chattahoochee into a commercial artery, all such efforts proved unsuccessful.

In 1851, to cite but one example, industrialist Barrington King, the founder of Roswell (which was then part of Cobb County), and several

Pierce's greatest service to the state, however, was as its principal early educational leader, serving as the first president of the Georgia Female College in Macon, Georgia (now Wesleyan College), the world's first four-year female college, and later, from 1848 to 1854, as president of Emory College. Pierce was next elected a Methodist bishop and assigned to the Arkansas-Missouri area but continued to maintain a close relationship with Emory, serving on its board of trustees and helping to raise money for the fledgling institution.

Pierce also sought to exercise a moderating spirit on the rising tide of southern sectionalism. As a delegate to the historic Methodist General Conference of 1844, which witnessed a north–south schism, he endeavored to temper the militant proslavery sentiment that threatened the church's unity. Only when his entreaties failed to have the desired effect did he, with reluctance, help organize the Methodist Episcopal Church, South. Pierce also opposed Georgia's 1861 secession from the Union. However, once the state committed itself irretrievably to withdrawal and became a part of the Confederate States of America, the Methodist bishop threw his support behind the Southern cause, declaring that "the triumph of our arms is the triumph of right, and truth, and justice." Although an owner himself, Pierce was never entirely comfortable with the institution of slavery and advocated reforms in the system. By 1863, he was advising outright repeal of the state's slave laws.

Pierce died on September 3, 1884, near Sparta, Georgia, where he was buried.

business associates organized the Warsaw Navigation Company with the goal of making the river navigable between the Western & Atlantic Bridge (erected in 1838 by the Western & Atlantic Railroad) and Winn's Ferry at Gainesville in Hall County to the north. Gainesville was the trading and supply center for the Georgia gold fields and thus an important potential market. This attempt ended, however, in abject failure.

Had the Chattahoochee River been rendered navigable for any considerable distance north and south of the W&A Bridge, the river would have carried much of the traffic and material intended for northerly locations, thus diminishing the importance of the river's various ferries, bridges and fords, as well as its principal north–south artery, Atlanta Road.

Ultimately, the area's transportation difficulties were largely resolved, not by the removal of the Chattahoochee's natural obstacles but by means of a massive public works project undertaken by the State of Georgia: the construction of the 137-mile-long Western & Atlantic Railroad, the first state-owned and state-constructed railroad in the United States, a project brought to fruition, with many fits and starts, between 1838 and 1851.

It was not only human traffic and the products of farms and manufacturing establishments that required a more efficient and inexpensive mode of transportation, but it was also the area's vast mineral resources. North Georgia contained a wealth of minerals, including iron and coal, but the means of transporting them inexpensively to the nation's manufacturing centers was lacking. Fortunately, the State of Georgia recognized the problem and attacked it boldly.

As early as the mid-1820s, the Georgia State Board of Public Works gave serious consideration to building a network of canals that would link the port of Savannah to Chattanooga on the Tennessee River and thus provide the mining district access to markets via the Atlantic Ocean, as well as the developing northwest. Even if such an ambitious scheme had been possible from an engineering standpoint, it quickly became evident that the cost would be prohibitive. Fortunately, the nation's fast-developing railroad industry provided a more practical solution.

The prime movers promoting the W&A railroad project were United States senator Wilson Lumpkin, a former governor of Georgia; Alexander Stephens, longtime U.S. senator and later vice-president of the Confederate States of America; and businessman Mark Anthony Cooper, often referred to as the "Iron Man of Georgia." As president of the Etowah Manufacturing & Mining Company, Cooper supplied most of the iron that was used in the construction of the W&A. The existence of the line, of course, enabled his

ironworks to distribute its products to a much wider market, thus ensuring its long-term success.

It was at first uncertain where the W&A would cross the Chattahoochee River. Eventually, its chief engineer, Stephen Harriman Long, selected the Montgomery Ferry site between Boltonville and Bolton as the most appropriate crossing point for a railroad bridge. There were no bridges of any kind across the Chattahoochee River into Cobb County until this span was built in 1838.

Now, a word about Long. A New Hampshire native, a distinguished topographical engineer, a military officer and one of America's greatest explorers, Long led five expeditions into the West in the period between 1817 and 1826, covering in all some twenty-six thousand miles. Long's Peak in Colorado was named in his honor. An inventor of steam engines, Long also helped found the American Steam Carriage Company and served as chief engineer in the construction of the Baltimore & Ohio Railroad before his selection to direct the Western & Atlantic project, a position he occupied from May 12, 1837, to November 3, 1840. Long laid out the route of the railroad and supervised its grading to the Etowah River. Unfortunately, his tenure as chief engineer coincided with the Depression of 1837, which slowed the progress of construction substantially, leading to disagreements with the railroad's board that, in turn, resulted in his resignation in November 1840.

Although the southern terminus of the W&A was initially projected for Bolton, a village on the south side of the Chattahoochee, the topography at Bolton was judged inappropriate for the laying out of a railroad yard and sheds. On that account, it was decided to locate the railroad's terminus instead some miles south of the river at a location at first called "Terminus" but later, in 1843, given the name Marthasville, after a daughter of Governor Lumpkin, before finally being dubbed Atlanta in 1845.

Interestingly, there was a much greater concentration of residents initially at the Bolton site. It was only after the inauguration in 1842 of regular service between Atlanta and Marietta, the principal population center in Cobb County, that Atlanta began experiencing the significant growth and development that turned it into the transportation and manufacturing hub of Georgia.

Atlanta's rise as a railroad hub was amazingly rapid. By 1854, no fewer than four lines converged on the nascent city from multiple directions—the Georgia Railroad (1845), the Macon & Western (1846), the Western & Atlantic (completed to Chattanooga in 1851) and the Atlanta & West Point (1854), thus giving the state of Georgia the most extensive railroad system in the South.

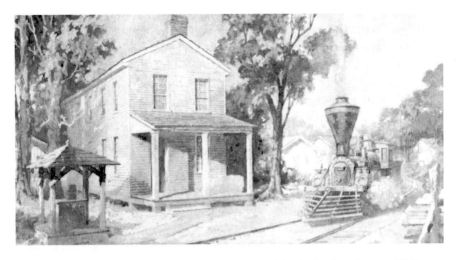

This two-story building, erected in 1842 on the north side of what later became Wall Street in Atlanta, housed the Western & Atlantic Railroad's engineering office, marking the southern end of the W&A. By 1842, the W&A extended through Smyrna to Marietta on a line paralleling present-day Atlanta Road. Illustration by Wilbur Kurtz. *Courtesy of Wilbur Kurtz III.*

Already by 1850, the population of Atlanta had risen to an impressive 2,500 at a time when Marietta contained only 1,500 residents.

A number of enterprising South Cobb residents built their fortunes in Atlanta, located only fifteen miles south of the Smyrna Campground. James A. Collins and his brother-in-law, James Loyd, offer two early examples. Collins resided initially in Boltonville on the Chattahoochee's north bank. Born in 1807 in North Carolina, he settled in South Cobb in 1833 at the age of twenty-six and was soon after elected a justice of the county's Inferior Court, serving in that capacity from 1834 to 1837.

In 1844, Collins and Loyd established a general store on Central Avenue in Atlanta, at the east end of Wall Street. Collins resided in Atlanta from 1844 until 1849 and then returned to Boltonville. Loyd also resided in Boltonville. The two men were thus among the earliest Atlanta commuters, traveling back and forth either by private horse-drawn conveyances or by train.

But it was in Atlanta that Collins and Loyd made their fortunes. The Collins-Loyd establishment was, in fact, one of the first general stores in the fast-developing city. So prominent was Collins in the affairs of early Atlanta that a street was named in his honor: South Collins Street.

Collins was also one of the wealthiest residents of South Cobb. His estate, valued at $6,000 in 1850, quickly appreciated to $22,445 by 1860

and included thirteen slaves. His name was given to a spring located on his property, and the spring's name, in turn, was applied to a church, also situated on his land—the Collins Spring Primitive Baptist Church, located close by Atlanta Road about one-third of a mile north of the Chattahoochee River. This church was founded in about 1850, and its members presumably used the adjacent Collins Spring for adult baptisms.

Collins, who died in 1862, a year after the outbreak of the Civil War, had apparently promised the local Baptists to deed them the property on which the church stood but somehow failed to do so. The promise was ultimately kept, however, by Collins's daughter, who in 1870 transferred title to the two-acre parcel on which the church stood to the congregation. Ironically, neither Collins nor any member of his family was a member of the church that perpetuated his name.

Despite the rapid growth of Atlanta, in the pre–Civil War era it was Marietta that exerted the greater influence on South Cobb. Marietta, the administrative center of Cobb County, lay only five miles north of the Smyrna Campground, while Atlanta lay fifteen miles to the south, with the Chattahoochee River in between. Marietta was fast growing and prosperous, although the scale of development there did not approach that of Atlanta. It was home, however, to nearly 15 percent of Cobb County's population and was the seat of local government. The completion of the first leg of the Western & Atlantic Railroad in 1842 had greatly stimulated its development, as did the construction in the following nine years of an additional one hundred miles of track to the north. During his tenure as chief engineer, Stephen Long made Marietta his headquarters. Moreover, the little city occupied an attractive, elevated and healthy location, sitting some 1,132 feet above sea level.

Residents of the more humid areas to the south increasingly turned to this attractive town in summer for relief from the heat, and Marietta developed a booming resort economy, filled with inns and hotels catering to the needs of these summer residents. By 1849, the prosperous town already contained four churches, representing the leading Christian denominations in the general area—Episcopalians, Methodists, Presbyterians and Baptists. An 1849 publication, *Statistics of the State of Georgia*, noted that "Marietta, from the advantages it possesses in point of situation, accessibility, climate, and water, is destined to be one among the most attractive places in our State."

Thus, a few miles north of the quiescent Smyrna Campground, the site where downtown Smyrna would eventually arise, lay this dynamic and

growing commercial center. Smyrna would rest comfortably and contentedly in the economic and political orbit of Marietta for the next hundred years.

The W&A did not begin providing regular service to Marietta until December 25, 1842, a twenty-mile run from Terminus. Nor did the W&A at first make regular stops at the Smyrna Campground, there being little patronage there in the early years. It was not until 1869 that a railroad depot existed there.

One should bear in mind that travel by train in the early years was a risky business—train derailments, engine explosions and fires were among the many hazards passengers faced. It is said that the passengers on this first trip to Marietta were so uncertain of the capacity of the W&A bridge to support the train's heavy engine, the Florida, that they preferred walking across the span to riding across. One of these passengers, interestingly, was eight-year-old Rebecca Latimer, daughter of a prominent DeKalb County planter, who as Rebecca Latimer Felton became the first female United States senator eight decades later in 1922.

It is also worth noting that the first hotel to open in the future metropolis of Atlanta, the Gannon House, was constructed in Boltonville in 1843 and was later transported by rail to the developing Atlanta—supported, as the story goes, in an upright position on two flatcars. We are told that the small hotel, which carried many of the men who had helped construct the building, narrowly missed toppling into the Chattahoochee River as it was hauled across the W&A bridge.

Only in 1850, in the face of almost insurmountable engineering difficulties (most notably the construction of a 1,477-foot-long tunnel that runs through the base of Chatoogeta Mountain), was the W&A finally completed all the way to Chattanooga, thus providing a commercial link to the west via the Tennessee River. In the same year, a telegraph line was installed along the W&A tracks, thereby integrating North Georgia into the national communications grid. With one fell swoop, an area of the nation that had previously been geographically isolated entered the mainstream of the nation's economic, political and cultural life.

Before the construction of the Western & Atlantic Railroad, there was little economic incentive to locate enterprises or residences in the area that would later become downtown Smyrna. However, the building of the railroad shifted the focus of development somewhat from Mill Village to the vicinity of the railroad. In the aftermath of the completion of the first leg of the W&A in 1842 came the construction of two key local landmarks on the Smyrna Campground: the 1846 Methodist Church, with its adjacent graveyard, now

the Smyrna Memorial Cemetery, and the Smyrna Academy, a tuition-based private school that by 1860 had an enrollment of 150 boys and girls.

This brings us to the question of names. As previously noted, the current downtown area was referred to from an early date as the Smyrna Campground. However, with the construction of the Western & Atlanta Railroad, other names were applied to the general area—Ruff's Siding, Varner's Station and Neal Dow, among others. The name Ruff, of course, derives from the entrepreneur Martin L. Ruff, who helped establish the Concord Woolen Mill in the late 1840s and who presumably transported goods produced at the Concord Woolen Mill to a railroad siding by wagon for transshipment. This siding is thought to have been located about where Windy Hill Road now intersects Atlanta Road. The name Varner, it would seem, derived from Matthew Varner, a prominent Marietta businessman, but it is unclear what was meant by the term "station" since no depot in the traditional sense existed at this location.

Neal Dow was the leading temperance advocate in the United States in the late 1840s and 1850s. It has been suggested that the name was applied at the suggestion of Stephen Harriman Long, the railroad's original chief engineer, but this seems unlikely. There is no evidence that the two men were acquainted. Moreover, Long's tenure as chief engineer ended in 1840, two years before service was initiated on the W&A line. The name was more likely applied to the area some years later, possibly between 1851 and 1855, when Dow's reputation as a prohibitionist was at its height.

It was in 1851, while serving as mayor of Portland, Maine, that Neal Dow secured enactment of the so-called Maine Law, the first state prohibition act, a legislative accomplishment that propelled him to national prominence. Dow was sometimes referred to in that period as the "Napoleon of Temperance." He lectured widely on behalf of prohibition. His various speaking engagements brought him into three southern states in the early 1850s. The two principal religious groups in the area—the Methodists and the Baptists—both strongly favored prohibition, so the application of the name Neal Dow to the location would presumably have met with popular favor.

In his subsequent career, however, Dow's name became unacceptable to many Southerners owing to three factors: the key role this Northern reformer played in founding the Maine Republican Party, which steadfastly opposed the extension of slavery into the U.S. territories; his service in the Union army as a brigadier general under the command of the much-hated General Benjamin ("Beast") Butler; and his advocacy in the postwar period of equal rights for blacks.

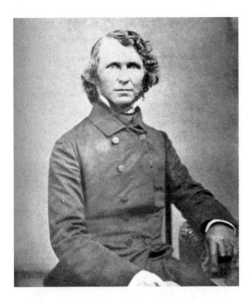

Neal Dow, mayor of Portland, Maine, the nation's leading prohibition crusader. The Yankee reformer's subsequent career as a Union brigadier general and postwar advocate of black rights made him a *persona non grata* in the South, whereupon all reference to his name disappeared.

Mention has already been made of the establishment of an academy at the Smyrna Campground at some point in the 1840s. Georgia was slow to move on the public education front. Such monies as the state appropriated for schools tended to flow into the hands of private academies, which were tuition-based institutions. By 1851, there were 216 state-chartered private academies in Georgia. The local one, Smyrna Academy (also referred to as the Smyrna Institute), was apparently established before 1846. Source information on the academy is very sparse. It was at first housed in a building that stood near the present-day intersection of Atlanta and Concord Roads, on the site where the 1911 Methodist Church would afterward be built. The school principal in its early years was Professor William Danforth, who the federal censuses tell us also engaged in farming. Danforth was succeeded, probably in the 1850s, by J.R. Mayson, a recent graduate of Emory College and a member of a prominent Atlanta family. By 1860, however, Mason, who was then only thirty-three years of age, had relinquished his post in Smyrna and was teaching school in Atlanta.

In the early 1850s, the academy was relocated to a new brick building that stood a few hundred feet north of its original location, a building that measured thirty-two by forty-four feet and faced south, backing up to present-day West Spring Street, which at that point did not yet exist. With the coming of the Civil War, the Smyrna Academy suspended operations to allow its male students to enter the service of the Confederacy. Unfortunately, the only pictures that we have of this singularly important local landmark show it as it looked at the turn of the twentieth century, long after the structure had ceased to accommodate the academy.

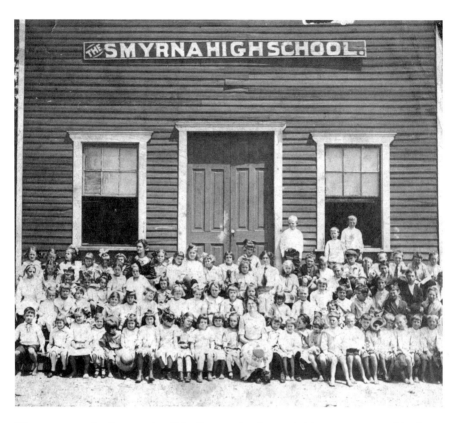

There are no early photographs of the Smyrna Academy, a brick structure erected in about 1850, long the most important building in what is now downtown Smyrna. The structure served as a hospital for a time during the Civil War. Here we see it as it appeared in about 1919, when it accommodated Smyrna High School. This singularly important local landmark was, unfortunately, replaced by a modern structure in the 1950s.

By late 1860 and early 1861, the people of Georgia were confronted with the possibility of secession stemming from the 1860 election of Abraham Lincoln of Illinois as the sixteenth president of the United States on a platform of firm opposition to the extension of slavery. In opting to secede from the Union and join the Confederacy, Georgia thrust itself into the greatest political and military crisis of American history, a crisis that led in 1864 to an invasion of the state by a powerful Federal army that wreaked havoc on much of the state. The Smyrna area and South Cobb stood squarely in the path of that juggernaut.

CIVIL WAR BATTLEFIELD, 1860–1864

While secession sentiment in Cobb County was mixed, as reflected in the positions taken on the issue by Marietta's several newspapers, in the end the movement to take Georgia out of the Union prevailed. All three of the county's delegates to the January 16, 1861 convention gave secession their support, and the ordinance was ultimately adopted by a vote margin of 166 to 130.

The Cobb County delegation that helped make this momentous decision consisted of Elisha Hamilton Lindley (1816–1876) of Powder Springs, a prosperous farmer; Georgia Superior Court judge George D. Rice (1805–1878) of Marietta, a Cobb political mainstay; and Albert Allen Winn (1812–1897) of Big Shanty (Kennesaw), who owned fourteen slaves and whose estate in 1860 stood at a substantial $20,500.

While unionist sentiment was much stronger in the mountainous region to the north, where small family-operated farms predominated and slave ownership was relatively thin, the majority viewpoint in the tier of counties bordering the Chattahoochee River favored secession.

Georgia's adherence to secession and, subsequently, to the creation of the Confederate States of America was of special importance. Without the participation of the "Empire State of the South," the economic and political viability of the Confederacy would have been gravely compromised. In fact, the Confederacy might never have emerged had Georgia rejected secession.

One need only glance at a map of the Confederate states to appreciate how critically important Georgia was to the success of this undertaking, for

the state was not only the largest and richest of the seven that originally adhered to the Confederacy, but it also constituted its geographical linchpin. Without Georgia's participation, the Confederacy, if it had taken shape at all, would have been divided into no fewer than three parts. South Carolina would have been isolated from the other East Coast member, Florida, and the four westernmost of the original seven (Alabama, Mississippi, Louisiana and Texas) would have been isolated from their two eastern sisters.

In short, a refusal on Georgia's part to secede in early 1861 had the potential of stopping the consolidation movement dead in its tracks. Such a refusal might well have dissuaded the border states of North Carolina, Virginia, Tennessee and Arkansas from seceding and joining the Confederacy as well.

But Georgia, of course, did secede, and as historians William W. Freehling and Craig M. Simpson noted in their book *Secession Debated: Georgia's Showdown in 1860*, with the "Empire State of the South" on board, the "projected Southern Confederacy had its Lower South hinge."

The conflict that ensued between the North and the South was nonetheless a highly uneven contest. Any objective observer of the strengths and weaknesses of the combatants at the war's inception would have had to concede that the South was burdened by vast material disadvantages.

For one thing, the Union benefited from having a far more diverse economy than did the Confederacy (ten times greater in manufacturing capacity than its adversary). It also had a more fully developed and efficient internal transportation system, enabling it to transfer men and supplies more quickly and efficiently than its rival. The North also enjoyed greater food producing capacity, for the South's agricultural economy was largely devoted to the production of inedible staple crops such as cotton and tobacco. The Union entered the contest, moreover, with an existing bureaucracy and diplomatic corps (and with the recognition of the great powers of the day, Britain and France, something the Confederacy aggressively sought but failed to attain).

The Union also began this mammoth struggle with an existing army and navy, while the Confederacy had to create its military organization largely from scratch. The North's greater shipbuilding capacity also allowed it to slowly but inexorably choke off Southern access to foreign markets and sources of supply.

However, nothing from this litany of Confederate disadvantages proved more decisive in the long run than the Confederacy's lack of manpower. While the twenty-two states that remained in the federal union had a combined population of more than 22 million residents, the eleven states of the Confederacy contained only 9.5 million people, nearly 4 million of whom

were slaves (and thus ineligible to serve in the Confederate army). While the existence of this large slave force mitigated the labor shortage at home, the manpower problem remained a fundamental Confederate disadvantage. From the beginning of the conflict, the Union enjoyed a roughly 4:1 superiority of manpower, and this substantial advantage increased over the course of the four-year struggle as portions of the Confederacy fell under Union control.

Also, while the North continued to attract large numbers of immigrants (mostly German, Irish and Scandinavian in this period), an element that enlisted in the Union army in disproportionately high numbers, relatively few immigrants entered the slave-owning South, and the minor prewar influx ceased almost entirely during the war years. An analysis of the 1860 Federal Census in the Smyrna area, for example, reveals only one foreign-born head of household—Frederick King (perhaps originally Friedrich Konig)—a well-to-do farmer who was a native of Germany.

Yet the Confederacy survived for four long years, and it was only with the greatest of difficulty that the Union ultimately prevailed. How are we to account for the Confederacy's longevity in the face of so many distinct Northern advantages?

One must remember, first of all, that Southerners were fighting to preserve a social order and a way of life that was under siege. The eleven states of the Confederacy sought independence in the 1861–65 period because Federal policies (especially in the aftermath of the election of Abraham Lincoln as president) threatened the region's unique social and economic order, founded on slave labor, a system critical to the continued economic well-being of the South's dominant planter class (it is worth noting that in 1860 slaves represented fully one-third of the value of all property in the South).

Equally crucial was the sense of panic of the white Southern population at large, which could not conceive of a society in which potentially dangerous blacks might be set at liberty.

Southerners fought harder than Northerners because they had so much more to lose. One should also bear in mind that the Confederacy was waging an essentially defensive war, mostly on its own terrain. Thus, its task was more straightforward than that of the Union. Southerners had only to repel Union forces long enough to persuade the people of the North, who had less of a material and emotional stake in the outcome, that continued warfare was futile.

The South Cobb economy, which had never produced much cotton, benefited initially both from the increased demand for food and fodder

SOLON Z. RUFF, 1837–1863

Solon Zachary Ruff was the single most important Civil War officer to emerge from the Smyrna area. Born in 1837, he was the eldest son of Martin L. Ruff and Judith Mead Lovejoy. Solon's father was the owner of Ruff's Mill on Nickajack Creek, the man who with Robert Daniell in 1847 founded the Concord Woolen Mill, the area's most important manufacturing establishment.

Ruff received his early education at the Smyrna Academy and then entered the newly established Georgia Military Institute (GMI) in Marietta, a school founded in 1851. The Georgia Military Institute was the principal training facility for engineers and teachers in Georgia during the decade leading up to the Civil War. Originally funded by private subscription and donations, it was officially chartered by the Georgia legislature in 1852. While the school began with only three instructors and seven students, it soon attracted a large number of cadets from some of Georgia's wealthiest families. In the period between 1853 and 1861, its student body fluctuated between 150 and 200 cadets.

Solon Ruff graduated from GMI in 1856, ranking second in his class, and subsequently joined the school's faculty as a professor of mathematics. With the outbreak of the Civil War, Professor Ruff was named lieutenant colonel and second in command of the Fourth Georgia State Brigade, better known as the Phillips Legion, a force commanded by Brigadier General William

that came with the outbreak of war and the availability of rail transport. The labor shortage (bearing in mind the area's relatively small slave population) no doubt retarded productivity to some extent, but the first two years of the war were nonetheless a period of relative economic prosperity for the area.

Despite its manpower shortage, Georgia contributed altogether more than 100,000 men to the ranks of the Confederate army. An analysis of the 1860 Federal Census for the Lemons Militia District (corresponding roughly to modern-day Smyrna, Vinings and the adjacent areas along the Chattahoochee) shows that virtually all the young white men of the neighborhood, and many of the older white men as well, were eventually inducted into Confederate service. The population of the sparsely populated Lemons Militia District, it should be emphasized, was quite small—consisting of only eighty-two households—so its pool of potential soldiers was correspondingly meager. Yet, as previously noted, most of the men in the sixteen to forty-five age range eventually rendered military service.

It was not until 1864, in the last full year of the bloody and destructive conflict, that North Georgia became a theater of war. The state's relative isolation from the

fighting in the war's first two years, coupled with its extensive network of railroads (some 1,400 miles of track altogether), had transformed Georgia into a veritable breadbasket of the Confederacy. Georgia also had more industry than most other Southern states, much of it related to the manufacture of textiles.

The 1864 invasion of Georgia by a large, experienced and well-equipped Federal army under General William Tecumseh Sherman—some 110,000 troops in all—was undertaken with the double objective of destroying the Confederate army under General Joseph E. Johnston and crippling Georgia's capacity to furnish food, fodder and manufactured goods to the war effort. Another of Sherman's objectives was to pin down Johnston's army, thus preventing it from reinforcing Robert E. Lee's forces in Virginia, then under relentless assault by a huge Federal force led by General Ulysses S. Grant. Both Confederate armies were substantially smaller than their Union counterparts, with the Confederate manpower dilemma worsening day by day.

Sherman had four reasons to be confident of success in North Georgia: the great numerical advantage Union forces enjoyed; an efficient supply system that kept his army fed, clothed and well armed; faltering Confederate morale

Phillips of Marietta, a close friend and ally of Georgia's Civil War governor Joseph Emerson Brown.

Phillips and Ruff were assigned the task of organizing camps in Cobb County for the instruction of officers and enlisted men. One such camp (Camp Brown) was established on the grounds of the Smyrna Academy building, where Solon Ruff had earlier attended school. This facility is said to have attracted many visitors during its brief existence.

Although Governor Brown initially intended this brigade for the defense of Georgia from a possible Federal invasion, in August 1861 he yielded to pressure from Confederate president Jefferson Davis and placed the legion under the control of the Confederate army.

Ruff commanded troops in the Battle of Antietam. On that one fateful day, September 17, 1862, the bloodiest of the entire war, an incredible 23,110 men were killed, wounded or listed as missing in action. In his September 23, 1862 report to his commanding officer, Ruff noted his role in the battle: "We carried 176 men into the action, and lost 101 in killed, wounded and missing...All the men and officers, so far as I was able to observe, acted with the most desperate coolness and gallantry. Not one showed any disposition, notwithstanding their terrible loss, to fall back or flinch from the enemy until they received orders to do so."

This gallant officer was himself killed in the fighting at Fort Saunders in Knoxville, Tennessee, on November 23, 1863.

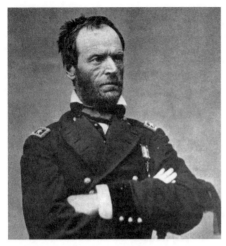
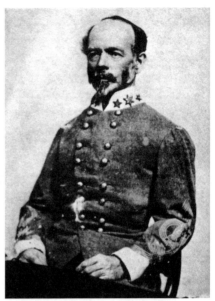

Left: General William Tecumseh Sherman, commander of the Union forces that passed through Cobb County in mid-1864.

Right: General Joseph E. Johnston, commander of the Confederate forces that sought unsuccessfully to repel Sherman's juggernaut.

stemming from the long series of defeats it had suffered during 1863; and finally, the propensity of the Confederate commander, General Johnston, to retreat before more numerous and better-provisioned opponents.

Another factor that undoubtedly contributed to General Johnston's reluctance to take the offensive was his poor relationship with Confederate president Jefferson Davis. The two disliked and distrusted each other. Davis regarded Johnston, with no small degree of justification, as an ally of his political opponents, while Johnston was convinced, virtually to the point of paranoia, that the president would use any significant military setback as grounds for removing him from command.

Thus, Johnston's strategy was essentially defensive. The campaign in North Georgia began in early May 1864 following a concentration of Confederate forces at Dalton, Georgia, just over the boundary from Tennessee. But upon learning soon after that Sherman had flanked his army and now threatened his rear, Johnson began moving south, first to Resaca, where an indecisive two-day battle was fought resulting in combined casualties of more than six thousand men. Other battles followed a similar pattern (Adairsville, New Hope Church, Pickett's Mill, Dallas and finally Kennesaw Mountain, where the Confederates succeeded in repelling a Union assault and significantly bloodying the enemy),

but each engagement, even Kennesaw Mountain, was followed by another Confederate retreat southward.

Sherman's most important short-term objective was the conquest of the city of Atlanta, the state's most important railroad and industrial center. Some historians contend that the fall of the "Gateway City," which occurred in September 1864, sealed the fate of the Confederacy. This view is reflected, for example, in the title historian Gary Ecelbarger gave his recent history of the Battle of Atlanta: *The Day Dixie Died.*

The strategic importance of the Chattahoochee River—the last significant physical barrier to Sherman's drive toward Atlanta—must also be emphasized. It gave the fighting that occurred in South Cobb greater significance than is typically attributed to this phase of the Atlanta Campaign.

Could Sherman's vast army have been stopped, or at the very least significantly delayed in its progress toward Atlanta, by a more aggressive Confederate defense at the Chattahoochee River?

With minimal resistance, Union forces occupied the city of Marietta, a scant twenty miles north of Atlanta, on the morning of July 3, 1864. Sherman had assumed, incorrectly, that Johnston's army would now make a headlong dash for the Chattahoochee. Sherman planned to quickly cross the river and make his next stand in the trenches that had already been constructed on the outskirts of Atlanta. Thus, the Union commander's goal following the taking of Marietta was to outpace Johnston's retreating forces; to seize the various Chattahoochee bridges, ferries and fords; and to severely punish the Confederates as they attempted to cross the river.

What Sherman did not know was that the Confederates, in the previous weeks, had constructed a strong line of fieldworks on a six-mile front about halfway between Marietta and the river extending from Nickajack Creek on the west to Rottenwood Creek on the east. The Battles of Smyrna Campground and Ruff's Mill were fought on this line on July 4, 1864, largely within the boundaries of the present city of Smyrna. The Confederates mounted a spirited resistance that they hoped would slow the Union advance, with the bulk of the fighting concentrated at the eastern and western ends of this front.

After shelling the Smyrna Campground area from Windy Hill, Union forces attacked this entrenched Confederate line where the W&A runs parallel to the campground, in the vicinity of present-day Roswell Street, but failed to break through. They also attacked the Confederates on a ridge along Nickajack Creek near Ruff's Mill at the western end of this front, with similar disappointing results. Union forces sustained heavy casualties

in these two sharp encounters, suffering 410 killed and wounded, and were temporarily stymied.

It is one of the fundamental beliefs of this writer that the fabric of history is very loosely woven and that chance occurrences often alter, sometimes quite dramatically, the course of history. The Battles of Smyrna Campground offer a telling example of the transformative potential of such chance occurrences. During this relatively minor engagement, General Sherman, the tactical genius who ultimately conquered Atlanta and then swept across Georgia in a destructive "March to the Sea," was very nearly killed on our home ground, an incident that he later related in his memoirs: "It was here [near Smyrna Campground] that General Noyes, late Governor of Ohio lost his leg. I came very near being shot myself while reconnoitering in the second story of a house on our picket-line, which was struck several times by cannon shot, and perfectly riddled with musket balls." A bullet was said to have passed through the brim of Sherman's hat in this near-death incident. Oral tradition holds that the house in question stood on Gilbert Street in the present Williams Park section of the community.

Another account, taken from the memoirs of General O.O. Howard, places Sherman's near-death experience in a wooded area near a farmhouse just east of the railroad on Windy Hill that was the headquarters of Sherman's subordinate, Major General David Stanley. According to Howard, Sherman and several of his officers were passing through the woods on horseback when they unexpectedly ran into a barrage of heavy fire from a set of Confederate works, and the commanding general was obliged to pass from tree to tree as he sought to escape to the rear.

Was this one incident or two? Whatever the case, one is tempted to speculate on the consequences that might have stemmed from the death of Sherman at this critical juncture in the war. The removal of this relentless, battle-tested commander would almost certainly have significantly slowed the progress of the Union army, thereby delaying or possibly even preventing a timely conquest of the strategically critical city of Atlanta.

Bear in mind three things: timing was of the essence here, for a presidential election was in the offing, scheduled for November 1864; General Grant, the other principal Union commander, was making little headway in his campaign against Robert E. Lee's forces in Virginia; and Union casualties were extremely heavy in the fighting there.

If the Union army had failed to take Atlanta in a timely fashion, the victory in the closely contested 1864 presidential election might well have gone to Lincoln's Democratic opponent, General George B. McClellan, who was

running on a peace platform that promised a negotiated settlement in the event of a Democratic victory. It was therefore most fortunate for Lincoln and his political allies that it was only Sherman's hat that was demolished in the fighting near Smyrna Campground and not the general himself.

Despite the stiff resistance that Confederate forces offered on the Smyrna line, the progress of the Union army was not long delayed there. Later on the same day, the Federals succeeded in capturing the first line of breastworks at Ruff's Mill, taking about 150 Rebel prisoners. By 2:30 p.m. on July 4, at least one Union corps had crossed Nickajack Creek and was in the process of flanking the Confederate left. By 4:00 p.m., Confederate brigadier general Lawrence Sullivan Ross had reported that "the enemy is moving around my flank…my position is no longer tenable."

A short time later, General Gustavus Woodson Smith, who commanded state troops, confirmed the danger and reported that he would have to pull back no later than daybreak unless reinforced. His left now seriously threatened after only thirty-six hours of resistance, General Johnston again ordered the bulk of his army to withdraw and take up a position behind the River Line fortifications that had recently been constructed on the Chattahoochee's north bank. These fortifications were a far more formidable obstacle than the entrenchments Union forces had encountered at Smyrna.

As Sherman noted in his memoirs, he had no inkling of the existence of the River Line fortifications prior to his arrival on the scene. "I confess I had not heard beforehand of the existence of this strong place, in the nature of a tete-du-pont, and had counted on striking [Johnston] an effectual blow in the expected confusion of his crossing the

A diagram by General Francis Asbury Shoup of the defensive line he constructed on the north bank of the Chattahoochee River, consisting of thirty-six interconnected "shoupades" (forts), in an unsuccessful effort to prevent Sherman's forces from breaching the Chattahoochee River.

Chattahoochee, a broad and deep river then to his rear. The Riverline proved one of the strongest pieces of field fortification I ever saw."

The River Line fortifications had been created over a period of a few weeks by Johnston's chief engineer, Francis Asbury Shoup. The use of slave labor to construct major public works projects had been a recurrent feature of the early history of the area. A large slave labor force had been utilized a quarter century earlier in constructing the Western & Atlantic Railroad. That railroad, now largely in Sherman's hands, served as a critical lifeline of his army as it advanced toward Atlanta. Had the Confederates succeeded in somehow severing the W&A, the progress of Union forces might have been slowed, but no systematic effort had been made to do so.

Now in mid-1864, as Union forces converged on the Chattahoochee River from the north, one thousand slaves were again pressed into service to build the massive River Line, arguably the most ambitious and solidly constructed set of fortifications the Confederates erected during the entire war and a singular engineering achievement. The River Line was devised and constructed by Shoup for the precise purpose of preventing Sherman's numerically superior, better-armed and better-provisioned army from making an easy transit of the Chattahoochee River.

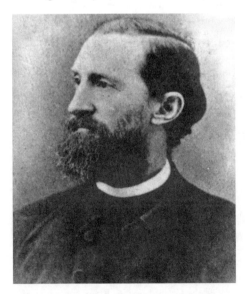

Francis Asbury Shoup was born in Laurel, Franklin County, Indiana, in 1834, the eldest of nine children of George Shoup, a wealthy merchant, and his wife, Jane. Francis attended Asbury University in Greencastle, Indiana, before entering West Point, from which he graduated in 1855. After leaving the academy, Shoup saw service in Florida, fighting the Seminole Indians, but retired from the army on January 10, 1860, to take up the practice of law in Indianapolis.

When the Civil War broke out in April 1861, to the surprise of friends who had assumed that Shoup, as a Northerner, would

Brilliant Confederate military engineer General Francis Asbury Shoup, who designed the impregnable "River Line."

join the Union army, the Indianan instead moved south, settling in St. Augustine, Florida. Declaring that he had "aristocratic inclinations and admiration for the South," he soon after entered the Confederate service.

In the summer of 1862, Shoup was elevated to the rank of brigadier general by the Confederate Congress but was soon after captured in the Battle of Vicksburg and briefly imprisoned. After his parole, he was transferred to Georgia, where he served as chief engineer of the Army of the Cumberland.

The River Line fortifications, which Shoup so artfully designed, were formidable in the extreme, comprising no fewer than thirty-six interconnected forts. As described by historian William R. Scaife in his 2004 essay "The Chattahoochee River Line," each of these forts was

> *diamond shaped in plan with two faces pointing in the direction of the enemy like an arrowhead. The forts were constructed after the fashion of log cabins, using double walls of logs filled with compacted earth. The exterior face walls were 10 to 12 feet thick at the base and extended to a height of 10 to 12 feet—surmounted by an infantry parapet or banquette for riflemen, for a total height of some 16 feet. These massive earthen structures could readily absorb the impact energy of artillery fire and were therefore virtually impregnable. Each was designed to be manned by a company of 80 riflemen.* [These] *strange looking structures came to be known as "Shoupades" in honor of their designer.*

The shoupades, which stood about 60 to 175 yards apart, were interconnected by a stockade of sharpened vertical logs embedded in the earth, rising some eight feet in height. About halfway between these forts, the stockades formed a reentrant angle broken by a redan, featuring two artillery pieces.

If Sherman attacked the shoupades directly, Shoup calculated, his army would suffer huge casualties, but if he instead sought to cross the river to the north or south of the River Line (the more likely scenario given his disinclination to attack entrenched positions), the Confederate force massed behind the River Line would be able to offer an effective resistance by a strategy of rapid and flexible response. This strategy might well have succeeded in significantly delaying Sherman had General Johnston not been so wedded to a purely defensive strategy.

Before moving on to a systematic description of the military activities that unfolded in and around the River Line between the first contact of Union

troops on July 6, 1864, and the largely unobstructed en masse crossing of the Chattahoochee by General Sherman's army only two days later, we should take note of the efficiency and speed with which the River Line was constructed.

Following a conference with General Johnston on the evening of June 18 at Kennesaw Mountain in which Shoup outlined his bold proposal, the engineer received authorization to construct the fortifications. That very evening, Shoup was dispatched to Atlanta by special train to begin assembling a force of slave laborers from surrounding plantations to carry out his plan. That slave labor force, which at its height numbered about one thousand workers, was quickly dispatched to the high ground on the north bank of the Chattahoochee with the required tools and provisions and was placed under the command of Major William B. Foster, senior engineer of General William W. Loring's corps.

Shoup and Foster together laid out the parameters of the fortifications about one mile on average from the river. This line extended from a point about one mile above the Western & Atlantic Railroad Bridge to a point some three miles below the bridge, terminating near the mouth of Proctor's Creek and extending in all about four miles. This amazing feat of construction was accomplished moreover in record time. There was ample timber available at the site, and as General Shoup afterward wrote, "The line sprang into existence as if by magic in a scant two weeks."

Shoup's recommended strategy, with its combination of defensive and offensive features, was not, however, implemented by Johnston. Instead, the overly cautious general once again pursued an exclusively defensive strategy by ordering the construction of an additional line of rifle pits southward for another nearly three miles from the main fortifications, with the objective of covering the crossing point at the Mayson-Turner Ferry. In adding these rifle pits, Johnston signaled his rejection of Shoup's recommendation that the troops massed behind the River Line be employed flexibly and offensively to resist any and all attempts by Union forces to breach the Chattahoochee. As Scaife wrote of this fateful decision, Johnston's rifle pits "changed the River Line fortifications from the compact bastion conceived by Shoup to a line over six miles long, made up of Shoup's new structures on the right [and] almost three miles of conventional earthworks on the left."

Policing the river in the manner Shoup advocated, it should be emphasized, would have been no easy task, since there were numerous potential crossing points in the vicinity—six ferries in the fourteen downstream miles below the Western & Atlantic Railroad Bridge and another seven fords or ferries above

the bridge, plus a wagon bridge at Roswell and another bridge six miles farther upstream at McAfees. To be successfully implemented, such a strategy would have required initiative, daring and a willingness of a commander to divide his forces and place some of his troops south of the river to forestall Union crossings—qualities that the more successful Robert E. Lee possessed in abundance but that General Johnston rarely demonstrated.

Sherman's massive army converged on the Chattahoochee River across a broad front. General George H. Thomas, commander of the Army of the Cumberland and the "Rock of Chickamauga," led his troops along the main road (Atlanta Road and the parallel Western & Atlantic Railroad) toward Shoup's fortifications, while General John Schofield, commander of the Army of the Ohio, and General James M. McPherson, commander of the Army of the Tennessee, reached the river to Thomas's right, below the Mayson-Turner Ferry.

General Oliver O. Howard, in the meantime, took possession of the "unoccupied and unguarded" direct route to Atlanta via Pace's Ferry and Buckhead. In addition, Sherman sent Brigadier General Kenner Garrard's cavalry some sixteen miles up the Chattahoochee with instructions to seize a key bridge and ford located there and then to cross the river and occupy the important industrial town of Roswell.

Before this could be accomplished, however, on July 5, the Confederate wagon train, shielded by Lieutenant General Joseph Wheeler's cavalry and under heavy Federal artillery fire, succeeded in crossing the Chattahoochee on two hastily constructed pontoon bridges. Once across, the bridges were cut loose to float to the southern shore, although one of them was carried by the current in the wrong direction and thus fell into Federal hands, a small consolation to Union forces that had allowed vital supplies, so critical to continued Confederate resistance, to escape their grasp.

Under instruction to engage the enemy immediately upon reaching the River Line, General Thomas ordered his troops into action, but as Sherman noted in his memoirs, they were met by a heavy and severe fire.

After a personal inspection, Sherman wisely ordered Thomas to disengage. He had no wish to replicate here, on the northern bank of the Chattahoochee, the bloody consequences of his assault on Kennesaw Mountain. He realized that the River Line defenses were virtually impregnable and that they had, in fact, been prepared with the hope of bringing on another futile Union assault.

Sherman's first impression of the River Line was reinforced by a conversation he had with a poor black man who had come out of the abatis blanched with fright a short time before. This man informed the general

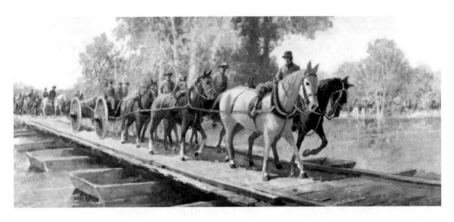

Here we see Union forces crossing the Chattahoochee River on a pontoon bridge in July 1864. Illustration by Wilbur Kurtz. *Courtesy of Wilbur Kurtz III.*

that "he had been hiding under a log all day with a perfect storm of shot, shells, and musket balls, passing over him, till a short lull had enabled him to creep out and make himself known to our skirmishers, who in turn had sent him back to where we were. He reported that he and about a thousand slaves had been at work for a month or more on these very lines, which… extended from the river about a mile above the railroad bridge to Turner's Ferry below, being in extent from five to six miles."

Rather than fall into the trap that Shoup had so artfully prepared, Sherman decided to avoid further attacks on the River Line and to instead move his army across the Chattahoochee as quickly as possible. First he ordered General James B. McPherson's army to march back across the Smyrna battlefield to Roswell. Then, on July 8, Schofield's force was sent in the same general direction, camping to the south of McPherson at Sope's Creek, some five miles above the River Line.

It was from Vinings Mountain on July 5 that Sherman had his first look at the prize city of Atlanta, now a mere nine miles to the south. Of the actual crossing of the Chattahoochee, which occurred at Sope's Creek on July 9, Sherman recounted:

> We had already secured a crossing point at Roswell, but one nearer was advisable; General Schofield had examined the river well, found a place just below the mouth of Sope's Creek which he deemed advantageous, and was instructed to effect an early crossing there, and to entrench a good position on the other side, viz., the east bank…Schofield effected his crossing at Sope's Creek very handsomely on the 9th, capturing the small guard that

was watching. By night he was on the high ground beyond, with two good pontoon bridges finished, and was prepared, if necessary, for an assault by the whole Confederate army.

Meanwhile, Thomas was instructed to demonstrate against the River Line to keep Johnston from responding to the Federal crossing that was in progress upstream. Johnston soon recognized the danger he now faced, with the Federals poised to take possession of the ground between his army and the Union's principal target, the city of Atlanta.

As Sherman wrote, "That night Johnston evacuated his trenches, crossed over the Chattahoochee, burned the railroad bridge and his pontoon and trestle bridges, and left us in full possession of the north or west bank besides which we had already secured possession of the two good crossings at Roswell and Sope's Creek." Sherman added significantly that "I have always thought Johnston neglected his opportunity there, for he had lain comparatively idle while we got control of both banks of the river above him."

Not long after Johnston's crossing of the Chattahoochee, Confederate president Jefferson Davis removed Johnston from command, elevating the more aggressive General John Bell Hood to that position, an officer who, with the Chattahoochee River now breached, proved totally incapable of holding back the invading Federals.

Interestingly, in his *Narrative of Military Operations During the Civil War*, a volume published in 1874 in response to the many criticisms that had been leveled at him for his lack of initiative, Johnston declined to provide much in the way of justification for his failure to use the River Line as Shoup had intended, merely commenting with regard to his precipitate withdrawal, "In consequence of this [the crossing at Sope's Creek by Federal forces], the Confederate army crossed the Chattahoochee in the night of the 9th (each corps had two bridges), and was established two miles from it."

Thus ended military activity in South Cobb, a campaign that, in hands more aggressive than Johnston's, might have salvaged the Confederate cause.

THE RECONSTRUCTION ERA, 1864–1872

How much physical damage did South Cobb sustain during the Atlanta Campaign? Local historians have made blanket statements about the total devastation the area experienced at the hands of the wanton Union commander, William Tecumseh Sherman, but much of the damage the area suffered during the Federal advance through South Cobb was an inevitable product of the fighting rather than an intentional effort on Sherman's part to destroy all Southern property.

These exaggerated accounts assert, for example, that after Sherman's army passed through Smyrna, the only building left standing was the Smyrna Academy and that Sherman spared that structure only because it was in use as a hospital for wounded Union soldiers.

This assertion loses sight of the reality of what Smyrna was in 1864. The village at that juncture contained only three public facilities: the Smyrna Academy; a stop on the railroad identified on the military maps of the period as "Smyrna Station," which may have been nothing more than a railroad landing; and the rather primitive log church that the Methodists had built in 1846.

As to the log Methodist church, its destruction came not during the Battles of Smyrna Campground but rather several months later, in October 1864, when Federal troops were withdrawing from the area to join the bulk of the army in its "March to the Sea," the second phase of the campaign, when Union forces were cut off from their supply base and were accordingly directed by Sherman to live off the land.

These artillery shells testify to the intensity of the July 1864 Federal assault on Smyrna. They were unearthed by Robert Baldwin, a local collector of Civil War memorabilia, on the Baldwin family farm, near the corner of Concord and King Springs Road in Smyrna.

Nor, it should be emphasized, was Sherman in the habit of making war on churches. He forbade the destruction of houses of worship in Atlanta, so the assumption that the church on the Smyrna Campground was intentionally burned by his orders seems suspect.

When Sherman intentionally destroyed property in northern Georgia, he did so with the objective of diminishing the war-making capacity of the Confederacy or, less often, making an example of those he considered to be particularly culpable Rebels. The most notable local instance of intentional destruction was the burning of the Concord Woolen Mill, the largest industrial facility in the area, a factory that manufactured textiles for use in the making of Confederate uniforms. Similar measures were taken in nearby Roswell, a major local industrial center. While the wooden structures that housed the Concord Woolen Mill were intentionally set ablaze on July 4 during the Battle of Ruff's Mill, it should be noted that privately owned structures, even property belonging to the owners of the Concord Mill, were left unharmed, including the homes of Concord Woolen Mill owner Martin L. Ruff, Ruff's gristmill and the residence of the miller.

While firsthand accounts of what transpired in Smyrna during and in the immediate aftermath of the Battles of Smyrna Campground and Ruff's Mill

are few, those that do exist confirm that Sherman's troops did not engage in indiscriminate destruction of private property in the Smyrna area.

While the historical record is admittedly spotty, the fate of the William Ireland homestead provides evidence that wholesale destruction was not part of Sherman's strategic agenda at this stage of the campaign. The Irelands resided on a farm situated less than two miles northeast of the Smyrna Campground, on acreage that now forms part of the Dobbins Air Force Base, and their farmhouse lay in the line of the Federal advance. Ireland, a forty-six-year-old farmer and millwright, was himself away fighting in the war, but his wife and four of their seven children then occupied the house and were urged by a Confederate army officer, acting under the orders of General Johnston, to abandon their home, which stood in the path of the advancing Union army.

One of these children, seven-year-old Edith Ireland, later known as Nettie Kinard, shared her recollections of that fateful day with an *Atlanta Constitution* reporter in December 1949 at age ninety-one:

> *An officer of the Confederacy had that day knocked on the door of…the Ireland place. "You'll have to be moving on ma'am," the officer declared, "The Yanks are pressing us pretty hard and 'pears like we'll have to be dropping back before long. Refugee train's are waiting down at the crossing and'll take you to Marthasville [Atlanta]. Don't take any more than you have to. It's a good policy to keep light and movable nowadays."*
>
> *When the fighting was all over and father and family were reunited, they went home again. The old home was there. The sturdy old Ireland home place which her father had built single-handedly, splitting tall pines and great oaks and planning them into smooth boards, weathered Yankee fire and gave the Irelands a starting point after the war.*

An unsigned memorandum, discovered in the vertical file of the Smyrna Public Library, describes how another local family living near the Smyrna Campground, the Browns, were influenced by the fighting. This undated account was committed to paper by a great-granddaughter of the family of N.C. and Julia Brown, who occupied a house at the eastern end of Church Street near its present-day intersection with King Street. Both N.C. and his eldest son, David, were serving in the Confederate army in Virginia at the time. The memorandum furnishes the following details as to how the women and children of the Brown family were affected by the approach of Sherman's forces:

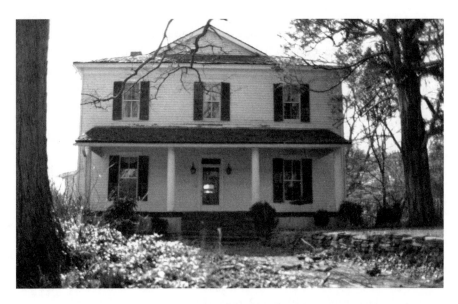

The Martin L. Ruff house, the home of the cofounder of the Concord Woolen Mill, built in the 1850s, one of many local buildings that survived the fighting near Smyrna. It stands at 86 Concord Road.

Soon the battle was being fought on Kennesaw Mountain and then on to Marietta and Smyrna. Great Grandmother [Julia White Brown] thought it best to leave home and take her five children with her to her brother's home in South Carolina. He owned a plantation there. She said, when they waited in Smyrna for the one train a day (the Rome Express) to go to Atlanta she could see the smoke and hear the cannons as the fighting drew nearer to Smyrna. Many homes and buildings were destroyed but her home was not damaged. After the war ended she came back home.

None of this is intended to suggest that the Smyrna area did not sustain damage as a result of the Battles of Smyrna Campground and Ruff's Mill—only that the destruction of property was not as extensive as earlier accounts have suggested or as thoroughgoing as the damage sustained in the state's commercial and industrial centers.

Another account of the conditions that prevailed in the aftermath of the fighting comes from testimony given in 1872 to the Federal Commission on Claims by local farmer Lazarus Dempsey, who owned a forty-acre property situated on the south side of Spring Street, through the center of which ran the tracks of the Western & Atlantic Railroad. The elderly Dempsey, who was seventy-five years of age at the time of his appeal, asserted that his property

had sustained major damage at the hands of Federal troops and asked to be compensated in the amount of $875 for his loss, a substantial sum at that time. Dempsey's total wealth in 1870, according to the federal census, was a scant $400. In his testimony before the commission, Dempsey declared:

> *I resided where I now live from the 1st of April 1861 to the 1st of June 1865. I owned a farm of 40 acres, about 10 acres in cultivation, the balance in woods situated on the Western & Atlantic Railroad fifteen miles from the City of Atlanta, the Rail Road runs through it. My occupation during the war was farming. I never changed my residence or business during that time, but when the fighting between the two armies commenced around my house, I went over into DeKalb County, but came back as soon as things got quiet again.*

To qualify for compensation, Dempsey had to swear that he had given no support to the Confederate cause:

> *I do solemnly swear, that from the beginning of hostilities to the end, my sympathies were constantly with the Union cause and I never of my own free will and accord did anything by word or deed to injure the cause of the Union or to retard the success of its armies and I was at all times ready and willing to aid and assist the Union and its supporters so far as the circumstances by which I was surrounded would permit.*

Dempsey asked to be compensated for the seizure of about two hundred pounds of bacon, a mule, the removal of a substantial amount of cut and uncut timber and the dismantling of his three-room farmhouse. The Spring Street farmer noted that he had been dependent before the war on the income from timber sales to the W&A Railroad. It should be borne in mind that wood was of critical importance to the contending armies, which were engaged in a struggle largely fought from behind entrenchments constructed of timber. Also, while the Confederates had crossed over the Chattahoochee River, there was no guarantee that they would not recross it to challenge the Federal position in Cobb, which they, in fact, did after the fall of Atlanta when General John Bell Hood turned his Confederate forces north with the goal of disrupting Sherman's sources of supply. Thus, the seizure of Lazarus Dempsey's timber was more a stratagem of war than an act of wanton destruction.

In the end, Dempsey's claim for federal compensation was rejected on the grounds that it was "by no means certain that the claimant was an adherent

Bushy Park, the elegant plantation home of diarist William King, situated a short distance south of Marietta Square. Bushy Park was demolished some years ago.

of the Union cause during the war." While several relatives and neighbors testified that he was a Union supporter, the commission could not bring itself to accept this testimony as valid, not only because there was no hard evidence to support his assertion of loyalty, but also owing to the fact that his eldest son, Reverend Alvin Green Dempsey, had served as a chaplain in the Confederate army and in the years since the war had become a leader of the Cobb County Democratic Party, which was working assiduously to reverse federal Reconstruction policies.

The people of South Cobb were, in fact, much more seriously affected by a shortage of food and the prospect of starvation than by indiscriminate destruction of their homes and property.

The diary of William King, which covers the period between July and September 1864, offers some insight into the suffering of local residents. King was a wealthy planter, the son of Roswell King and Catherine Barrington King of Roswell. In 1864, he was living on a ten-thousand-acre plantation called Bushy Park, located a short distance south of Marietta Square. No home within the boundaries of present-day Smyrna was of a comparable scale to this grand antebellum residence.

On July 18, 1864, two weeks after the fighting at Smyrna Campground, King noted in his diary:

The whole country [is] *in a lawless condition, citizens and soldiers of both armies all alike availing themselves of the distracted state of the country, committing all depredations of plundering and murdering—these are the unavoidable results of war, and which I had foreseen and foretold before this sad and needless war was commenced by politicians.*

Five days later, King took note of an elderly couple that had come to Bushy Park from the vicinity of the Smyrna Campground:

An old man and wife who live near Ruff's Station…made me a visit, they say they have been pretty much robbed of everything and they have been trying to get to [Marietta] *to get something to live on, but they would not be allowed to go in* [by occupying Union troops]*; that they had some corn but there was no mill to grind, that some of the soldiers told them that we had a hand mill here, and asked me if we would allow them to grind on it. I told them that they or any of their neighbors could do so…They said they would come on Monday with corn to grind. How great and many are the sufferings of the poor.*

In attempting to gauge the responsibility for the physical damage that the Smyrna area sustained during the war, one must bear in mind the context in which these incidents unfolded. In the aftermath of the fighting, Cobb County experienced a breakdown of civil order as marauding bands of Confederate troops, defeated and dispirited, seized property. In the words of Cobb County historian Sarah Temple: "Outside the government of the state of Georgia, shut off from the outside world by the destruction of its facilities for transportation and communication, the county became the prey of marauding bands of robbers which met with but little resistance in their bold and comprehensive depredations."

Governor Joseph Emerson Brown noted of this breakdown of authority in the autumn of 1864: "It is a matter of extreme mortification to know that a large part of our cavalry force…have left their commands and are now… robbing and plundering the citizens indiscriminately."

In short, many factors besides the general destruction of property by Federal troops contributed to the impoverishment of Cobb County.

What was true of the Confederate states generally in the immediate postwar period was true of South Cobb as well: a precipitous decline in property values and a general economic paralysis. A comparative analysis of the 1860 and 1870 Lemons District censuses provides dramatic evidence of the severe economic impact of the war.

In 1860, the year before war broke out, the average property value (real and personal property holdings combined) of the residents of the Lemons district stood at $3,775. In 1870, five years after the war ended, the average value of property holdings stood at a mere $1,220, less than one-third of what it had been a decade earlier.

Many factors contributed to the impoverishment of the area: war-related property damage, the emancipation of the area's slaves, a drastic reduction in the value of land, the repudiation of Confederate currency and securities and the unavailability of the credit needed to effect the physical reconstruction of the area. In the course of the war, tens of thousands of patriotic Southerners had liquidated their investments to purchase Confederate and Georgia securities, which the defeat of the Confederacy had rendered worthless.

Had the federal government had the foresight in 1865 to institute a reconstruction program along the lines of the post–World War II Marshall Plan, much of the suffering that prevailed in the South in the postwar period might have been avoided. While many of the programs undertaken by the Radical Republicans during their brief ascendancy were commendable on their face—the goal of providing universal education, for example—in the absence of substantial federal assistance, such measures placed an insupportable financial burden on Southern whites that served to exacerbate the bitterness many felt toward the federal government.

One clear indicator of the decline in local prosperity was a corresponding decline in the financial holdings of the area's wealthiest residents. Not only were South Cobb's men and women of means poorer in 1870, but there were also fewer of them. While in 1860 there had been twelve individuals in the Lemons District with a total wealth exceeding $5,000, by 1870 only seven enjoyed that level of fortune. The only individuals of means appearing on both the 1860 and 1870 censuses were Robert Daniell and Martin L. Ruff, the cofounders in 1847 of the Concord Woolen Mill. The woolen mill had been destroyed by Sherman's army in 1864 but was reconstructed and reopened by the partners in 1868. The two men were, however, substantially less wealthy in 1870 than they had been a decade earlier—$12,000 poorer in Daniell's case and $5,000 poorer in Ruff's.

While industrial employment increased slightly in the immediate postwar years, the vast majority of local residents remained farmers or farmhands—some 164 in all. And while property values plummeted, the number of households increased substantially, almost doubling from 82 to 157. One should bear in mind, however, that 20 of these new households (12.7 percent of the total) consisted of blacks; that none of these black households owned the land

on which they resided; and that their average wealth was only sixty dollars, with several reporting no property holdings of any kind.

There would also seem to have been less mixing of the races in the postwar period. Only 9 of 137 1870 Lemons District households included black domestic servants, cooks and farmhands. Blacks were largely reliant on their whites neighbors for access to farmland and employment. With so many Confederate soldiers killed or incapacitated in the war, white farmers had little choice but to rely heavily on the area's black labor force. Of 118 blacks who resided in the district in 1870 (in a total population of 821) 20 were farmhands, 5 were cooks, 4 were washerwomen, 3 were day laborers, 2 were house servants, 1 was a railroad hand and 1 other was a carpenter (Jesse Green by name, possibly the only skilled worker among them).

ROBERT DANIELL, 1813–1881

Robert Daniell, the area's leading industrialist, was born in Clarke County, Georgia, in 1813 and is reputed to have been the great-grandson of a colonial governor of both South and North Carolina. As previously noted, Daniell joined Martin L. Ruff in founding the Concord Woolen Mill on Nickajack Creek late in 1847. The two men developed a complete mill community at this site called Mill Grove that included a school, a church, a general store and a post office.

The Union army burned the Concord Woolen Mill on July 4, 1864, during the Battle of Ruff's Mill because it had been manufacturing woolen uniforms for the Confederate army. However, in 1868, Daniell and Ruff rebuilt their factory. On March 2, 1869, the Marietta Journal *described this facility as "[o]ne of the greatest enterprises that Southern ingenuity and capital has brought into existence." "Machinery was brought in from New York," the paper noted, "and skillful and efficient machinists are engaged in putting it up ready for operation." The reconstructed woolen factory was projected, according to this account,*

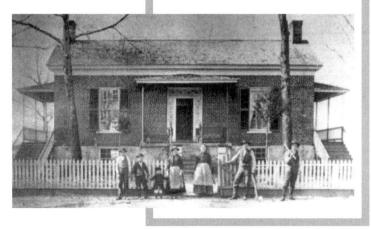

The Robert Daniell House, dating from 1872, is situated on Concord Road near the Daniell family cemetery.

to contain thirty-two looms and six hundred spindles, which it was hoped would provide constant employment to fifty-two operators, as well as other laborers.

By 1870, the Concord Woolen Mill was the largest employer in the Lemons District, with a total of sixteen local workers, ahead of the W&A Railroad, which ranked second in that regard. By August 23, 1871, according to an ad in the magazine The Plantation, the factory was manufacturing "cashmerelles, cassimers, and jeans." Its main office was located in Atlanta, and the agent for the mill was identified as J.B. Daniell. The ad also noted that the Concord Mill's offices were located in the Gram Block at the corner of Broad and Marietta Streets and that it was offering "exchange cloth for wool on liberal terms."

In 1872, Daniell and Ruff sold the Concord Woolen Mill to three Atlanta businessmen: Zachary A. Rice, James H. Porter and Seymour B. Love. By 1873, the facility was producing "40 different kinds of jeans and cashmeres," and in the 1880s, it won prizes for excellence in quality and design at exhibitions and trade shows throughout the country.

Daniell built himself a new residence on Concord Road in 1872. It was constructed of brick manufactured on the premises and timber that was cut from the surrounding woods. He was also a progressive farmer—the first in the area to raise one hundred bushels of corn to the acre.

The enterprising and innovative Robert Daniell died in 1881 and is buried at the Daniell Family Cemetery located off Concord Road, near Mill Grove.

An additional seven blacks resided at the Cobb County Poor Farm, situated just north of Smyrna Campground, along with, but not necessarily alongside, the institution's six white inmates. The superintendent of the poorhouse in 1870 was David H. Whitfield, age fifty-nine.

It may also interest the reader to learn that the black families in the Lemons District often adopted the names of prominent white families, presumably because they had formerly been owned by the family in question or because of a continuing economic dependence on that family. The surnames adopted by these freedmen included the names Pace, Daniel, Turner, Gann, Ruff and Varner.

The serious economic and social problems that confronted Cobb County and the Lemons District in the immediate aftermath of the war were only gradually overcome. The most pressing concern was the reconstruction of the Western & Atlanta Railroad, the area's main artery of trade and communication. This was accomplished largely under U.S. Army auspices within a few months time. The restoration of the area's farming and industrial economy proved much more difficult owing to a severe shortage of credit.

In the meantime, a battle was being waged in Washington

between those advocating the immediate readmission of the Confederate states to the Union with few preconditions (President Andrew Johnson and his Democratic allies advocated these policies)—the so-called Presidential Reconstruction program—and those who demanded that the freedmen be afforded a measure of protection under the U.S. Constitution. Left to their own devices, southern whites enacted "black codes" that effectively reduced the freedmen to a state of quasi-slavery.

The Georgia black code applied to any person who was deemed to have as little as one-eighth black ancestry. It barred blacks from voting, holding office or serving in the state militia. Most importantly, it imposed a severe contract labor system, with harsh vagrancy provisions, on the state's black population. Once arrested and convicted of vagrancy, an offender could be hired out to private persons or forced to work on public projects. The provisions of these labor contracts were rigidly enforced. The object of the black codes was to restore, to the fullest extent possible, the antebellum social and economic systems that the Emancipation Proclamation, the Union victory and the Thirteenth Amendment to the federal constitution (adopted on December 6, 1865) threatened to undermine.

Although some high-ranking former Confederate officeholders and military leaders were excluded from participation in the political process under the program, the legislative bodies that fashioned the black codes, it should be emphasized, were exclusively white in composition. In addition, Charles J. Jenkins, the governor elected in late 1865 without black participation, steadfastly opposed ratification of the Fourteenth Amendment, which sought to guarantee equal protection under the laws to the freedmen. Jenkins had little trouble persuading the white-dominated Georgia legislature to reject ratification (only two votes were cast in the General Assembly in favor of the Fourteenth Amendment).

These attempts to perpetuate the old social and economic order, to substitute via the black code de facto slavery for the outlawed institution, infuriated the vast majority of northerners, who in the fall of 1866 voted heavily Republican, delivering a political blow to President Andrew Johnson from which he and his administration never recovered.

In the 1867 session of Congress, with the triumphant Republicans now holding more than two-thirds of the seats (bear in mind that most of the former Confederate states were not yet represented there), the national legislature adopted the First Reconstruction Act, thus initiating so-called Radical Reconstruction. This 1867 enactment divided the former Confederate states (with the exception of Tennessee, which had already ratified the Fourteenth

Amendment) into five military districts, placing a senior officer of the U.S. Army in command of each one. General John Pope commanded the Third Military District, which included Georgia, Alabama and Florida and was headquartered in Atlanta, until 1868, when he was replaced by General George Gordon Meade. Some twenty thousand federal troops were assigned to the five districts to oversee the reconstruction process.

The southern states were directed to ratify the Fourteenth Amendment as a prerequisite for readmission to the Union. The 1867 act also banned former Confederate leaders and those who declined to take an oath of allegiance to the United States from voting or from holding office. As a result, almost as many blacks as whites became eligible to vote in Georgia (98,507 blacks versus 102,411 whites). A referendum was then held to authorize the drafting of a new state constitution, which was approved because most whites, at the urging of Georgia's intransigent governor, boycotted the process. Jenkins then sought to challenge the legality of the 1867 act in the federal courts, but his suit was rejected.

Of all the states of the former Confederacy, it was Georgia's white population that proved most resistant to black participation in government, but owing to the 1867 Reconstruction act and the presence of federal troops in the state, Georgia was temporarily obliged to yield. The 169 delegates (predominantly Republicans; 37 of them black) who met in Atlanta on December 9, 1867, to draft a new state constitution did a creditable job in the estimation of most modern historians. "This body of generally reasonable men builded well, and the constitution they wrote was perhaps a better framework of government than the Bourbon-Redeemer constitution of 1877 that replaced it," according to historian Kenneth Coleman in his 1977 work, *A History of Georgia*.

The 1868 Georgia state constitution provided for the cancellation of the many debts contracted during the war (a popular measure with the small farmer element), as well as the establishment of a free public school system for all the children of Georgia, irrespective of race. By 1870, fifty-seven children—white and black alike—were attending public schools in the Lemons District.

In April 1868, those eligible to vote approved the new constitution by a margin of 88,172 to 70,200, while also electing a Republican businessman, Rufus Bullock of Augusta, as governor over Confederate war hero General John B. Gordon in a close race. General Gordon, who is said to have headed the Georgia Ku Klux Klan, later played a leading part in the 1871 overthrow of the Bullock administration, becoming a major political leader

in the state in the three decades that followed and serving as U.S. senator from 1871 to 1880 and again from 1891 to 1897 and as governor of the state from 1886 to 1890.

Bullock had a singularly difficult time as governor, was falsely accused of corruption and in 1871 was obliged to resign and flee the state, although he later returned, settled in Atlanta and scored a great success as a businessman.

So intransigent did Georgia prove in its resistance to black political participation that the Radical Republicans in Congress required the state to ratify both the Fourteenth and Fifteenth Amendments (the latter stipulating that the right to vote should not be denied to anyone on the basis of race) as a precondition for representation in

Rufus Bullock, the Republican businessman who held the office of governor of Georgia from 1868 to 1871 but was ultimately forced to flee the state by the so-called Redeemers.

Congress. It was not until February 1871, ten years after it seceded from the union, that Georgia was again fully represented at the national level.

The local parameters of the political struggle of the Reconstruction period are difficult to gauge owing to an absence of documentation. We do know that three Lemons District men attained a degree of political prominence in these years. The town's only physician, Dr. William R. Bell, was one such. Bell at first threw in with the Republicans, but he eventually modified his stance and served as a delegate to the 1872 Liberal Republican National Convention that nominated Horace Greeley, with Democratic concurrence, to oppose President Ulysses S. Grant in his bid for reelection. John McAfee, Lemons District's only lawyer, on the other hand, and the previously mentioned Reverend Alvin Dempsey became Democratic Party stalwarts.

Chapter 5

A FAILED SUBURBAN VISION, 1872–1905

Smyrna was incorporated as a municipality by an act of the Georgia General Assembly in August 1872. It is not clear where the initiative for incorporation originated. The town's government at its inception was composed of a mayor (initially called an intendant) and four councilmen (initially called aldermen). These officials were also referred to in the act of incorporation as "commissioners." All five were identified by name in the legislation. There is no record of consultation with the residents of the town in creating this political entity. Nor is it clear that all of the commissioners were residents of Smyrna.

Smyrna was the fourth of Cobb County's cities to be incorporated, having been preceded by Marietta in 1852, Powder Springs in 1858 and Acworth in 1860. The incorporation of Smyrna, moreover, came in the immediate aftermath of the assumption of power in Georgia of the "Redeemers," signaling the final defeat of Radical Reconstruction and the reemergence of a white-dominated social order. The act of incorporation further stipulated that the town would hold its first election on the first Saturday in July 1873 and then annually thereafter.

The population of Smyrna at the time was tiny. Eight years later, in 1880, when the first post-incorporation census was conducted, the town's residents numbered only 255. Why was Smyrna, a community with so few residents, given a municipal form of government in 1872? In the absence of early town records and of newspaper coverage of the event, a definitive answer cannot be given.

The initial boundaries of the town were fairly generous, extending a mile in all directions from Smyrna's geographical hub, the Smyrna Academy building, giving the new corporate entity a circular configuration enclosing 2,560 acres. The town's density in 1880 was exceedingly thin at one person for every 10 acres.

Does the background of the five men who were named by the General Assembly to administer the affairs of the town during its first year of operation offer any clues into what prompted incorporation?

Smyrna's first chief executive, John C. Moore, worked for the W&A railroad. The thirty-five-year-old Moore had moved to Smyrna from Marietta at some point between 1870 and 1872 and was thus a relative newcomer. He and his wife, Rebecca, had six children, ranging in age from four to fourteen. The 1880 census lists Moore as a "railroad conductor," while his eldest son, George, age twenty-two, held the post of "express agent." Another son, Richard, was employed as a "machine shop worker" and was probably also a W&A employee. In short, the Moores were a railroad family. They resided, moreover, as did many dependent on the W&A for a living, on Roswell Street near the Smyrna Depot, a facility dating from 1869.

Apart from these few facts, we know little about Smyrna's first mayor, who lived out the balance of his life in the town, dying there in 1897 at age sixty. He and several other family members are buried at the Smyrna Memorial Cemetery. As late as 1910, two of his daughters were still living in Smyrna, where they operated a boardinghouse, probably out of their parents' former residence on Roswell Street, renting rooms to railroad employees.

It was perhaps with a view to giving the state-owned W&A a voice in Smyrna's government that the legislature chose Moore as the titular head of Smyrna's first government. The railroad was a major employer in the town. It ran through the center of Smyrna, paralleling Atlanta Road. Local farmers, who were still a distinct majority of residents in 1872, were dependent on the railroad to get their crops to market. The economic viability of Smyrna, as well as its prospects for growth, was intimately bound up with the W&A.

Of the four aldermen named in 1872, only two—Dr. William R. Bell and E.D.L. Mobley—are reliably traceable through the various federal census schedules. The other two—G.P. Daniel and W.L. Davenport—do not appear on either the 1870 or 1880 schedules. Efforts to trace them through later censuses and the Marietta and Cobb County papers proved fruitless. These individuals may not have resided in Smyrna at all. It is not clear that residency was initially a requirement for holding town office. Bell and Mobley, however, left an ample paper trail.

Dr. William R. Bell, a longtime resident of the town, was both a physician and an ordained minister. In 1870, he was also a trustee of the Smyrna Academy. Bell was an influential Cobb County political leader. Forty-six years of age in 1872, he was married and was the father of eight children. Dr. Bell was also a wealthy man, with 1870 property holdings totaling $16,000, half of it in the form of cash or securities. He was the third-wealthiest resident of the Lemons District and the wealthiest resident of Smyrna at the time of its incorporation. Unfortunately, this key figure died in 1876 at the relatively young age of fifty, only four years after the town's foundation. Like his colleague John C. Moore, Dr. William Bell is buried at the Smyrna Memorial Cemetery. His grave there proclaims him "Minister, Physician, and Statesman."

E.D.L. (Ephraim David Lovejoy) Mobley, was perhaps the most important of the five commissioners. A thirty-seven-year-old realtor, with offices in Atlanta, Mobley had grown up in the town. His residence, a fifteen-acre estate called Sedgefield, was situated at the heart of present-day downtown Smyrna. Smyrna's present city hall sits on what was formerly the Mobley estate. E.D.L. commuted to his Atlanta office by train on a regular basis. He embodied the suburbanizing vision that I believe motivated the projectors of Smyrna's 1872 incorporation.

The projectors of incorporation believed that Smyrna had immense potential for suburban development. The two principal arteries of transportation in Cobb County—Atlanta Road and the W&A Railroad—ran through the center of Smyrna. The town was situated only fifteen miles north of Georgia's fastest-growing metropolis, Atlanta, and only five miles south of Cobb County's principal commercial center and administrative hub, Marietta.

Rowena Daviddie Mobley, daughter of E.D.L. Mobley, a member of Smyrna's original town government that was established by an act Georgia General Assembly in 1872. *Courtesy of Mayor Max Bacon.*

Smyrna was also, by all accounts, a physically attractive location, covered with groves of handsome oak trees. The five Smyrna commissioners and their allies in the General Assembly recognized the potential for suburban development in this well-situated and attractive location and sought to foster that development potential by providing the area with a local government.

E.D.L. Mobley was already living the lifestyle he hoped to foster in Smyrna. The following detailed description of Sedgefield, written at some point in the early 1880s by E.D.L.'s daughter, Rowena Daviddie Mobley, paints an attractive portrait of suburban living:

> We had ten acres in [Sedgefield], and as the house sat far back, we had a nice lawn in front. On each side of the front walk near the house were two large flower beds filled with many pretty roses, chrysanthemums, pinks, thrift, and many other pretty flowers. In the center of these beds were large golden arborvitae, which my father kept trimmed like a cone. Farther down the walk were two more of the cone-shaped arborvitae. Below these, on either side of the walk were a lawn and a croquet ground. The lawn was shaded by a very large oak tree, which papa climbed when a boy; also two walnut trees. The croquet ground was shaded by large oaks also. There were seats under these trees. Way up the walk was a little vine-clad cottage. On the left hand side of the cottage was a large pear tree which was a delight of our children, for we had a swing in it and a doll house under it, where many a brilliant doll wedding took place. On the right hand side was the Academy drive so called from the situation of it to the Academy, being just outside of the gate. On each side of the drive were Samson trees. There was another drive called Cherry avenue being bordered on each side with cherry trees. We had many kinds of fruit—grapes, pears, peaches, apples, scuppernongs, raspberries, strawberries, currants, walnuts, persimmons, figs, mulberries, etc. We also had a pecan-tree. The rest of the place was cultivated in vegetables. Papa named our place Sedgefield.

However, the hoped-for influx of Atlanta-based businessmen and the anticipated suburban building boom simply failed to materialize. This was partly owing to the severe depression that settled on the nation in 1873, the effects of which lasted well into the early 1880s, but also to a lack of commitment on the part of the general population of Smyrna to the suburban vision of the town's incorporators. Notably, none of the original five commissioners was elected to office by the voters in the first town election following incorporation, held in July 1873. Smyrna's second

mayor, Pliny R. Fleming, was neither a railroad employee nor a realtor nor a speculator in securities. Instead, he was a farmer, and his colleagues on the first elected town council were either farmers or local storekeepers—a slate of officeholders far more representative of the majority of the town's population than the initial unelected group had been.

The townspeople were simply unwilling to appropriate money for the kinds of improvements that well-to-do suburbanites were demanding of their local governments. Tax avoidance became a political mantra in Smyrna, an attitude that persisted for decades and doubtless slowed development because the improvements suburbanites demanded—such amenities as a good road system, a public water supply and quality public schools—cost money. By 1883, Mobley himself had given up hope of rapid suburbanization and moved his family to West End, an upscale Atlanta suburb, although he did retain Sedgefield as a country retreat.

Only in the late 1890s—a quarter of a century later—were a number of Atlanta families of means lured into establishing country residences near Smyrna, but to a district outside the boundaries of the town, a section called Creatwood, about which we will have more to say ahead.

It should be emphasized that the powers and responsibilities of town government were quite limited in the early years. There was no municipal police force, per se, and no fire department, and the town's unpaved roads were maintained largely by adjacent property owners or by county chain gangs. There was as yet no public water supply (residents drew their water from individually owned wells), sewerage was nonexistent and there was no street lighting of any kind. In the absence of such services, taxes were virtually nonexistent. What little revenue the municipality gathered came from licensing fees and fines. This state of affairs persisted for the next several decades. Municipal services were only very gradually expanded. As late as 1926, more than half a century after Smyrna's incorporation, the town's annual budget stood at a meager $7,500.

Smyrna did experience some modest commercial development in these years, as noted in a September 2, 1873 article appearing in the *Weekly Constitution*, an Atlanta newspaper. The article described Smyrna's downtown as then containing a single church (the reconstructed Smyrna Methodist Church) and the Smyrna Academy, a facility, the article noted, that was in "flourishing condition" and administered by Mr. Baker as principal and a Mr. McClatchey as his assistant, both educators of "acknowledged ability." Within a few years, however, the academy had become a tuition-based public school housing both elementary and high school divisions.

"In noticing the business houses at Smyrna," the newspaper description continued, "we find George Eidson, dealer in family groceries, V.R. Cantrell & Company, dry goods and groceries; Harden & Son, dry goods and groceries, and all are doing good business judging from the frequent delivery of goods at the depot consigned to the different merchants." Clearly a small measure of commercial development had taken place since the war's end.

Some residential development occurred as well, but far less than Smyrna's visionary incorporators had anticipated. It was noted that Mrs. Solon Z. Ruff, wife of the Civil War hero, was building a beautiful cottage in Smyrna and that Major Zachariah A. Rice, an Atlanta manufacturer and land speculator (Rice later purchased the Concord Woolen Mill), was investigating the possibility of residential development in the area.

New churches were established in Smyrna in these years. A Presbyterian church was organized in 1874 and operated for many years out of a portion of the academy building.

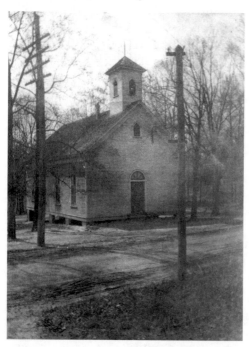

The Smyrna Baptist Church, dating from 1886, stood at the northeast corner of Atlanta Road and Powder Springs Road. It served the local Baptists until 1924.

While there were already several Baptist churches in the general area, none of them was particularly convenient to the residents of downtown Smyrna—the Concord Baptist Church (1832), the Collins Spring Primitive Baptist Church (circa 1850), the Maloney Primitive Baptist Church (1852), the Bethel Baptist Church (1867) and the Olive Springs Baptist Church were all located several miles away. As Harold Smith noted in his *Centennial History of the First Baptist Church*, "for the Baptist people living in Smyrna, going to church meant a ride in a horse drawn wagon or buggy, on a dusty or muddy road. The time involved going to and from one of the outlying church[es],

all of which were several miles from the center of town, could be a number of hours…depending on the weather."

Thus, Smyrna's First Baptist Church was founded in 1884, destined to become the single largest congregation in the town. The prime movers in the establishment of this church were T.E. Legg and Benson A. and Fanny Bell. The first meeting of the new church was held in the Presbyterian church in the academy building, evidencing a fairly high degree of fellowship among the early religious societies of the town. In 1886, the Baptist church was installed in a wooden structure at the northeast corner of Atlanta Road and Powder Springs Street.

The only policing function specifically authorized by the 1872 act of incorporation was the power to prohibit the manufacture and sale of alcohol. All three of the religious denominations that established churches in Smyrna before 1900 strongly supported prohibition. The Methodist Episcopal Church Board of Temperance, Prohibition and Public Morals was a major force in the American temperance movement. The records of the First Baptist Church attest to that denomination's concern to stamp out the twin sins of drinking and swearing. The Presbyterians likewise took a strong, if somewhat less militant, stand on the issue. Thus, Smyrna's three churches were bastions of prohibition sentiment.

None of this is intended to suggest that illegal liquor was not being produced and consumed in quantity in Smyrna, despite the disapproval of the clergy. In the troubled agricultural economy of the late nineteenth and early twentieth centuries, farmers depended on the manufacture of distilled liquor to enhance their meager incomes.

The consumption of illegal liquor continued to be a serious challenge even after the adoption of statewide prohibition, which took effect on January 1, 1908. The State of Georgia spearheaded the twentieth-century movement to outlaw alcoholic beverages, doing so a full decade ahead of national prohibition, but it did not eliminate liquor from the lives of the people of Smyrna. Liquor was readily available to those who desired and could afford it, and drunkenness was the most commonly committed misdemeanor in Smyrna.

While the town's commercial center expanded in the last quarter of the nineteenth century, Smyrna remained very much an agricultural village in these years. Farming was still the dominant economic activity. Forty-eight of the town's eighty-three gainfully employed residents, some 58 percent of the total number, identified themselves as farmers in 1880. Only nine residents, 11 percent of Smyrna's workforce, engaged in commercial or industrial activities, while another 10 percent worked for the railroad.

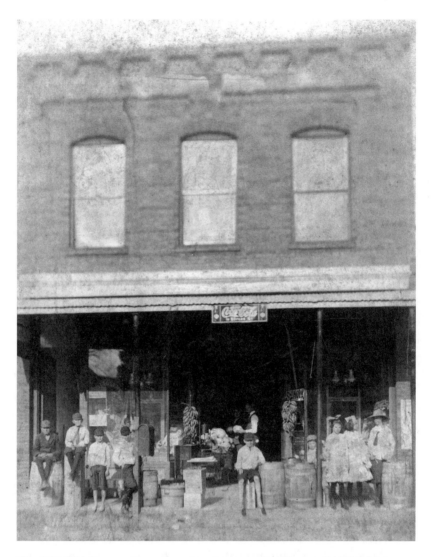

The Whitfield Grocery Store, owned and operated by Thomas W. Whitfield, dating from the early 1880s, occupied a prominently situated brick structure that stood on the east side of Atlanta Road in downtown Smyrna. The one-hundred-year-old structure was razed in the late 1980s in the first phase of the downtown demolition process.

While no maps or directories exist to document the number of stores that existed in the nascent downtown, the 1880 census listed several new merchants. William N. Pace was one such. Pace long maintained an establishment at the northeast corner of Atlanta Road and East Spring

Street, which may well have been there as early as 1876. Another grocer whose name appears on the 1880 schedule, John M. Stone, later operated a general store at the corner of Atlanta Road and Nickajack Avenue (a street later renamed Sunset Avenue and which ran through the site where the Smyrna Public Library and Community Center now stand).

A third prominent businessman, Thomas P. Whitfield, likewise appears on the 1880 schedule, listed only as a "grocery clerk" at the time. Whitfield is believed to have launched his career as a grocery store proprietor in the early 1880s.

Another merchant who established himself in the downtown at about this time was Matthew Gilbert, who had recently arrived from Fulton County. Gilbert resided on the street that now bears his name.

In addition, seven residents belonged to the town's small professional class in 1880: Joel Mable, schoolteacher; Henry C. Dodd, physician; William C. Connolly, physician; William P. Harden, physician; Robert R. Harden, physician; Mary M. Holbrook, schoolteacher; and Alvin G. Dempsey, minister. One or more of these men were probably medical apprentices or pharmacists. Robert R. Harden, for example, was only twenty-two years of age and was living with his father, Dr. William P. Harden.

The 1880 census also tells us that fifty-seven of Smyrna's residents were "at school." Interestingly, several of those attending Smyrna High School were nonresidents boarding with Smyrna families. On April 6, 1877, the *Marietta Journal* described the high school's student body as including eight "foreign students," signifying young people who came from other nearby Georgia communities. The article went on to say that there was room for more "foreigners, if they would only come," noting that Smyrna "is a beautiful place for a school and we think it is as free from the usual temptations to immorality as any place in Georgia."

The first published history of Smyrna, a slim volume of memoirs authored in 1967 by Mazie Whitfield Nelson, the daughter of storekeeper Thomas P. Whitfield, furnishes additional details about the downtown at the turn of the twentieth century. "Miss Mazie," as she was known, was born in 1890. A former schoolteacher, businesswoman and town librarian, she remembered that a cotton warehouse and gin called "The Jangaree," belonging to a Mr. Raswell (probably merchant Edward Baswell), stood on the railroad tracks just north of the Smyrna Depot, about where Williams Park is located today. This structure was destroyed in a spectacular fire, she recounted. She also mentioned a diagram of the village that her older sister had drawn in about 1900 depicting a substantial cluster of buildings as then standing, including

Matt Ruff's Gin, one of several cotton gins that serviced the Smyrna area in the early twentieth century. It stood on Atlanta Road, although its precise location is uncertain. The woman in the photo is Belle Petty. The photo is believed to date from the 1928–30 period. *Courtesy of Michael Terry.*

"churches, schools, stores, and residences." Clearly, downtown Smyrna was growing apace in these years.

The Jangaree was one of several cotton gins in Smyrna. On September 30, 1897, the *Marietta Journal* took note of another gin then under construction by local farmer and merchant Captain John T. Pace that the paper described as "the most expensive [improvement] made in Smyrna in several years, amounting to something over three thousand dollars." This may be the same gin, pictured here, that Matthew Ruff later owned and operated on Atlanta Road. The existence of these ginning establishments shows the degree to which Smyrna's economy was still tied to the production, processing and marketing of cotton at the turn of the twentieth century.

The community also developed institutionally in these years. In addition to its three active churches, all situated downtown, important secular organizations or lodges sprang into existence. An 1873 *Weekly Constitution* article identified one such lodge, a fast-growing chapter of the Order of Good Templars, an organization largely concerned with temperance and anti-liquor agitation, which it noted was "attracting young and old alike…earnestly laboring for the suppression of the liquor trade." The Templars apparently welcomed both men and women into their ranks, although the organization was riven with controversy over the inclusion of blacks and the organization of separate black lodges.

In December 1886, a second important lodge was founded downtown, the Nelms Masonic Lodge, established by a group of eighteen men representing

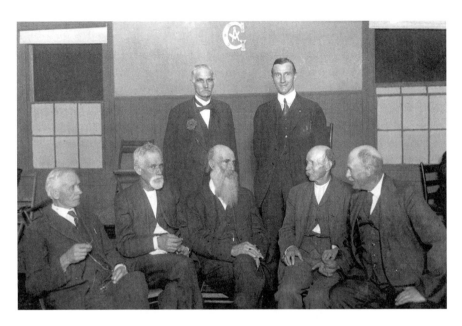

Here we see several of the charter members of the Nelms Lodge of Masons, in a photo dating from 1921. *Seated, left to right:* Judge John Stone; W.H. Baldwin, great-grandfather of Michael Terry; John H. Cantrell, farmer; Newt Dodgen, mill owner; and R.A. Eaton. *Standing, left to right:* Dr. W.T. Pace and Mark Ruff. *Courtesy of Michael Terry.*

a broad occupational cross section of Smyrna's population. Notable among its founders was its namesake, John W. Nelms. A vigorous promoter of Masonry in Cobb County, Nelms personally financed the first two years of the Smyrna lodge's operations. Other charter members included local farmers John H. Cantrell, Thomas W. Hooper, Rufus A. Eaton, James Love and William H. Baldwin; and three of the town's leading merchants, John M. Stone, John L. Reed and Thomas P. Whitfield, father of Mazie Whitfield Nelson. Whitfield became the lodge's first worshipful master. Other founders included gristmill owner J.N. Dodgen, teamster John W. Irelan and an employee of the Concord Woolen Mill, Benjamin F. Mackey.

The Nelms Masonic Lodge made its home initially in Legg Hall, situated near the corner of Atlanta Road and Powder Springs Street, adjacent to the First Baptist Church. It was later moved to a two-story building of its own construction downtown, the first floor of which was outfitted as a schoolroom. When that building burned down in 1924, the lodge purchased the old Smyrna Academy building from the town as its new headquarters.

In 1897, Smyrna's boundaries were cut back radically as a means of avoiding the costs associated with extending services to the outlying areas

of the town. Whereas formerly Smyrna had encompassed a generous 2,560 acres, as a result of this cutback, its area was reduced to a mere 640 acres, a quarter of its former size. Smyrna maintained these much-reduced dimensions until the early 1950s. As a result of this reduction in size, the town actually had fewer residents in 1900 (238) than it had had two decades earlier in 1880 (255). The 1897 cutback also reflected a total abandonment of the suburban vision that had impelled the town's incorporation in 1872. There can be little question that the cutback was a shortsighted decision, for the early years of the twentieth century, as we shall see, provided enhanced opportunities for suburban development, which the town was less well equipped to exploit by virtue of its reduced size.

The Smyrna area attracted a number of prominent Atlanta families in the late nineteenth century, many of them residents of West End, one of Atlanta's most fashionable suburbs, the community to which the Mobleys had moved in 1883. Several West End families built country homes in the Bowie Woods area, a mile or two south of the downtown area.

The Turners were among the first of these summer residents on the edge of Smyrna. The neighborhood was eventually given the name Creatwood, an acronym based on the first letter of each of five surnames: Crowe, Ray, Eubanks, Anderson and Taylor. The first use of the name Creatwood dates from about 1905.

The family of William Micajah Taylor (1853–1899) built a house (now known as the Taylor-Brawner House) in Creatwood in the early 1890s. Micajah's older brother, Stephen A. Taylor, likewise built a summer residence in that neighborhood.

It was Stephen Taylor's son, Henry, a resident of Spokane, Washington, who shipped a supply of narcissus/daffodil bulbs (also known as jonquils) to his father in Smyrna. The Taylors shared these bulbs with neighbors until virtually every yard in Smyrna was filled in the spring with these handsome yellow blooms. So prevalent did jonquils become in Smyrna that in 1949 the name the "Jonquil City" was officially adopted by the town.

Dr. Walter A. Crowe, a professor at the Southern Medical College and leading Atlanta obstetrician, also brought his family to Creatwood in these years. Dr. Crowe's father had been a prominent stock raiser. Beginning with a few cows, which Dr. Cowe was said to have purchased for the entertainment of his children, the doctor eventually established the well-known Creatwood Dairy Farm, which became in time one of the largest dairies north of Atlanta. A popular restaurant called the Guernsey Jug was later established at this location by members of the Crowe family.

The Guernsey Jug Restaurant, owned and operated by the Crowe family at the Creatwood Dairy, stood on the north side of the heavily traveled Dixie Highway (Atlanta Road) about two miles south of downtown Smyrna. The popular eatery served food produced on the Crowe property and advertised itself as "the best place to eat between Miami and Chicago." *Courtesy of Pete & Lillie Wood.*

Also of special note were the Campbells. In 1890, the wealthy and socially prominent Atlanta businessman Richard Orme Campbell (1860–1912) bought eighty acres of land situated on the east side of Atlanta Road about two miles south of downtown Smyrna as a country estate. Campbell had established in 1884 the highly successful R.O. Campbell Coal Company, which eventually developed into the largest such enterprise in the southeastern United States.

Campbell named his estate Argyle Farm. Campbell Road crosses the property today. The name "Argyle" derived from the Scottish Duke of Argyle, from whom the family claimed descent. Over the years, Campbell added many more acres to this extensive property.

In 1892, Campbell married Harriet Bunn Wimberley of Twigg's County, Georgia. Their eldest child, Isolene, born in 1893, attained considerable social prominence in Atlanta.

Isolene Campbell was educated at the Lucy Cobb Institute (an elite boarding school) in Athens, Georgia, and finished her education in New York. She then traveled extensively in Europe, where she witnessed the 1914 German invasion of Belgium. Upon returning to Atlanta in 1916, the

DR. JAMES NEWTON BRAWNER,
1876–1959

Dr. James Newton Brawner was born in Troup County, Georgia, the eldest son of James Middleton Brawner, a farmer, and his wife, Mary. From an early age, the boy showed an interest in medicine and was accordingly apprenticed to Dr. Henry Slack of LaGrange, Georgia. In 1895, at the age of nineteen, James Brawner entered the College of Physicians and Surgeons in Baltimore, Maryland, where he earned a medical degree. Particularly interested in the treatment of rabies, a common disease of the time in rural districts, Dr. Brawner traveled to Paris and spent six months observing the treatment of that disease at that city's famous Pasteur Institute. The Pasteur Institute was widely recognized for its successful treatment of

Dr. James Newton Brawner, the man who established the Brawner Sanitorium in the Creatwood area south of downtown Smyrna in 1910. *Courtesy of Michael Terry.*

socially active young woman became the principal organizer and first president of that city's prestigious Junior League. "It seemed absurd," she said later, "that we should be only thinking of the gay social whirl…while the memories were still fresh in my mind of the harrowing scenes I had witnessed as I came through France, Belgium, and England."

In 1922, Isolene Campbell married Major William Jay McKenna, owner of a Boston-based paint company. The McKennas had three children: William Jr., Harriet and Campbell. They resided in Boston's fashionable Back Bay in the late 1920s and very early 1930s, but in 1936, Isolene divorced her Yankee husband and moved back in Atlanta, where she resumed her involvement in the civic and philanthropic life of the city. She married a second time, just after World War II, to Max Don Howell.

It was Isolene Campbell McKenna who opened a general store/antique shop in 1941 in one of the Argyle Farm cabins that eventually became the famous Aunt Fanny's Cabin Restaurant. However, the Atlanta socialite proved a poor businesswoman, and by 1947, accumulating tax difficulties obliged her to sell the

restaurant, which flourished in other hands.

Ironically, the Atlanta-based Campbell family is more extensively memorialized in Smyrna than any of Smyrna's local families—in Campbell High School, Campbell Middle School, Campbell Road and the Argyle School, among other Smyrna place names.

The most significant of the Creatwood residents, however, was unquestionably Dr. James Newton Brawner, who bought the Taylor estate in 1908 and in 1910 established the Brawner Sanitorium (or Hospital) on its grounds. Readers desiring to know more about the Taylor and Brawner families and the Brawner Hospital are referred to Michael Terry's excellent book, *A Simpler Time: The Story of the Taylor-Brawner House and the Brawner Hospital*.

a whole range of diseases and related mental afflictions. The approach to the treatment of mental disorders that Brawner witnessed in France convinced him that the prevailing practice in the United States—confinement of the afflicted in mental asylums—was counterproductive. Upon his return home in 1900, he established the Georgia Pasteur Institute in Atlanta. For the next several years, Dr. Brawner worked with state officials to combat rabies, helping to establish hundreds of clinics to treat that dreadful disease.

Dr. Brawner married Nellie V. Barksdale of Jonesboro, Georgia, in 1902. The marriage produced three children. For the next several years, he built a highly successful medical practice in Atlanta.

Dr. Brawner's association with Smyrna began in 1908 when he purchased the eighty-acre Taylor estate just south of Smyrna, not as a seasonal retreat for his family, as had been the case with earlier arrivals, but rather as a site for a psychiatric hospital. In 1910, Brawner opened the first privately owned psychiatric hospital in the South in Smyrna. The Brawner Sanitorium was conducted on the advanced principles that Dr. Brawner had observed in Europe and had read about in the works of pioneering psychiatrist Dr. Thomas Story Kirkbride.

EMBRYONIC SUBURB, 1905–1930

At the beginning of the twentieth century, only a handful of relatively affluent Smyrna residents commuted to jobs outside of town. The modes of transportation available to those desiring to travel even a modest distance were limited to horses, horse-drawn conveyances or the relatively expensive and inconvenient rail service offered by the Nashville Chattanooga & St. Louis Railroad (as the old W&A had been called since 1890).

Smyrna then was still an agricultural village, tied economically to farming and the processing and marketing of farm goods. The population had, in fact, grown very little in the twenty-eight years since the town's 1872 incorporation. Most of Smyrna's residents worked on the land, in the town's few stores and shops or, in the case of the town's black residents, as day laborers, domestics, cooks and washerwomen.

The decades that followed, by contrast, saw Smyrna develop into a thriving commuter suburb. In the period between 1905 and 1930, the town's population increased nearly fivefold and at a faster rate than either Atlanta or Marietta. As the *Marietta Journal* announced as early as 1908, Smyrna had entered a "boom period."

This amazing transformation from agricultural village to emergent commuter suburb stemmed chiefly from the introduction of two new modes of transportation: streetcars and motor vehicles.

The twenty-mile-long trolley line from Atlanta to Marietta (officially known as the Atlanta Northern Railway) initiated service in 1905, thereby furnishing Smyrna's residents with an inexpensive and convenient means

of reaching its urban neighbors while also generating growth not only in Smyrna but in the villages along the streetcar line's route—Fair Oaks, Oakdale, Gilmore and Boltonville, among others.

For the residents of Smyrna, Marietta was now just a twenty-minute trolley ride away, while downtown Atlanta was only forty-five minutes away. The trolley provided the people of Smyrna with ready access to the commercial outlets of its larger neighbors for the first time, as well as greatly expanded employment opportunities. The impact of the trolley on Smyrna was, in fact, little short of revolutionary.

The second transportation-related development, ultimately even more transformational, was the introduction of motor vehicles into the area. Car and truck ownership gave Smyrna's residents an even greater range of commuting options.

Proliferating motor vehicle ownership led inexorably to major improvement and expansion of the area's network of roads. The laying out of Georgia's first interstate highway—the Dixie Highway, extending from Florida to Chicago via downtown Smyrna—funneled large numbers of tourists into the area. Moreover, by 1920, the Atlanta Road segment of the Dixie Highway had been hard-surfaced, providing the town with its very first paved roadway. Still, as late as 1924, only two Smyrna Streets were paved: Atlanta Road and adjacent Spring Street.

By 1920, one in five of Smyrna's workers was riding the trolley or driving to jobs outside of town. Most of these workers held jobs in factories or offices in or near Atlanta and Marietta. The places of employment included a chair factory, a marble works, a furniture factory, a paper mill, a machine shop, a plow factory, a candy factory, an automobile plant, a box spring factory, an overall factory, a foundry, a steel plant, an oil company and a furnace manufacturing company.

Industrial employment opportunities within the town, on the other hand, were quite limited—a handful of jobs at the Southland Ice Plant on Roswell Street, at the Pearl Springs canning factory on West Spring Street, a small- venetian blind and screen manufacturing shop on East Spring Street, a blacksmith shop in the downtown, several automotive repair shops and a coal yard on Atlanta Road just south of the downtown furnished the only industrial employment opportunities in the town itself.

The commuting element also became potential customers for a whole range of new technologies and services—prerequisites of suburban living such as city water, electric power, natural gas, street lighting, sewerage, in-door plumbing, improved public education and telephone service. The

town's first telephone exchange opened in the same year that trolley service was introduced. By 1930, eight Smyrna residents were working for the telephone company, while another twenty-nine were employed by Georgia Power in a variety of capacities.

The growing commuter element also assumed a leadership role in town government. Curtis L. Groce, a pattern maker at Atlanta's King Plow Company, served on the city council for three terms in the 1920s; W.A. "Lon" McBrayer, foreman in a glass factory, held a council seat in the 1921–22 period; Reuben G. Ray, manager of a Lumber Company, served on the council in the 1922–25 period; and, most notably, Henry H. Arrington, foreman of a mattress factory, held a council post in 1928 and 1929 and then served as mayor from 1933 to 1937.

Another prominent commuter was Hugh L. Marston. An executive clerk with the NC&StL Railroad, Marston commuted to Atlanta on a daily basis by automobile. He held the post of councilman from 1927 to 1928 and was deeply involved in a broad range of civic activities.

Owning an automobile allowed the town's only resident physician, Dr. William T. Pace, to reach patients who lived in remote corners of the Smyrna district. Until his death in 1932, Dr. Pace—who resided on the east side of Atlanta Road, opposite and slightly to the north of its present-day intersection of Concord Road—was reputed to have been the first Smyrna resident to acquire a car. Son of a former mayor and father of a future mayor, Pace himself held the mayoralty in 1912 and served in the Georgia General Assembly from 1929 to 1932. The Paces of Smyrna, in fact, constituted a local political dynasty in the first half of the twentieth century.

Owning a car made it possible for other Smyrna residents to make a living as traveling salesmen. The salesman about whom we know the most was Carl Terrell, an electrician who resided on Roswell Street and traveled extensively, installing and repairing elevators. We owe our detailed knowledge of his commuting activities to the diaries that his wife, Bess, kept between 1927 and the early 1940s. Born and brought up on a family farm on Terrell Mill Road, a few miles northeast of Smyrna, Carl Terrell met his future wife, Bess Embree, in Omaha, Nebraska, on one of his periodic sales trips.

In 1927, Terrell moved Bess and their two children, Robert and Helen, into a house he had built in 1906 on Roswell Street for his widowed mother, Buena Vista Terrell. The traveling electrician continued making lengthy sales trips by car until the depression of the 1930s undercut the demand for his services. Like his neighbor, Hugh Marston, Carl Terrell was prominently involved in the civic life of Smyrna, serving as worshipful master of the Nelms

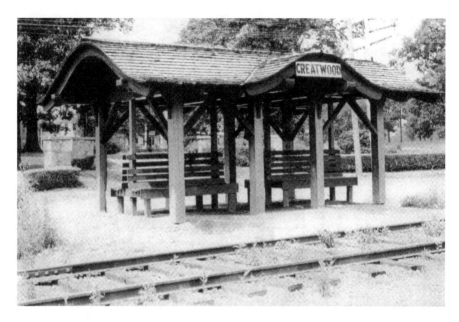

The Creatwood stop on the Atlanta to Marietta Interurban Trolley line stood in front of the Brawner Sanitorium. *Courtesy of Michael Terry.*

Masonic Lodge, as town clerk in the early 1940s and as city councilman in the 1950s.

The transportation revolution also stimulated Smyrna's commercial development. Several gas stations and auto repair shops opened along Atlanta Road in these years to accommodate both local car owners and tourists traveling along the Dixie Highway. Motor courts and restaurants sprang up in the area as well.

Trips to Marietta by trolley and car became routine for Smyrna residents. The Terrell diaries document the frequent shopping trips that Bess and her neighbors made to Marietta, as well as the not infrequent expeditions to Atlanta, where an even larger array of consumer products was available.

A number of new structures were built downtown in this period evidencing Smyrna's enhanced economic and social vitality. These included a trolley substation on the east side of Atlanta Road; a handsome new railroad depot at the East Spring crossing dating from 1907; the Bank of Smyrna (the town's first bank), which opened its doors in 1911 at the northwest corner of Atlanta Road and Bank Street; a beautiful new edifice for the Smyrna Methodist Church, also dating from 1911 and situated at the corner of Church Street and Atlanta Road; a Presbyterian church at the corner of

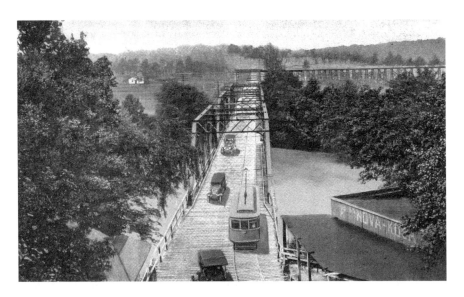

This postcard view showns a combination of trolleys and motor vehicles crossing the Chattahoochee River Bridge about 1925.

Church Street and Concord Road, dating from 1915; and a new First Baptist Church, constructed of Stone Mountain granite, which was dedicated in 1924 at the corner of King and Church Streets. Of these early twentieth-century structures, only the First Baptist Church, which is now utilized as a chapel, is extant.

Still, the town's tax base had not yet reached a point where it could support professional fire and police contingents. While Smyrna's police and fire departments underwent reorganization in the late 1920s, the improved police force still consisted of just two daytime officers and one nighttime officer, while the fire department, which continued entirely voluntary, began paying its members a small amount for each fire they attended in an effort to encourage a readier response.

The town also took steps in the late 1920s to resolve its water supply deficiencies. Before 1928, Smyrna's water needs were met chiefly from privately owned wells. The frequent droughts that the area suffered led to occasional shortages. The town had resorted to various strategies over the years to enhance its water supply, none very successful. As early as 1908, the *Marietta Journal*'s Smyrna column noted, "Smyrna is putting in waterworks by degrees, slowly but surely. We have actually two public pumps in town, dug a new one last week. All you have to do," the Smyrna correspondent declared naïvely, "is get enough of these pumps and you have waterworks."

The water supply problem remained largely unresolved until October 1927, when the town authorized a bond issue of $35,000 (an enormous expenditure at that time, the total annual town budget then being well under $10,000) for the construction of its first water supply system, consisting of several deep wells, pumps, a community cistern, a water tower and pipes to carry the water to individual subscribers.

Notably, the voters approved this project by a lopsided vote of 170 to 27 in 1927. This improvement was made during the administration of Mayor Patrick M. Edwards, a young and energetic wholesale grocer. A number of other important improvements were also initiated during Edwards's mayoralty (1927–30), including a December 1928 zoning ordinance (Smyrna's first major zoning initiative) that forbade unsightly businesses from locating within one hundred feet of Atlanta Road without a permit from the mayor and council.

These measures, while important, represented only a promising beginning. Many problems remained to be resolved when the Great Depression halted the process. Most of Smyrna's streets were still unpaved in 1930. Some streetlights had been installed, but most of the town's roadways were still without nighttime illumination. The town had few sewers in 1930, and only a handful of homes had as yet been furnished with indoor plumbing. Outhouses were still almost universal, a state of affairs that doubtless contributed to frequent outbreaks of epidemic disease.

Then there was the public education problem. In 1907, the *Marietta Journal*'s Smyrna correspondent qualified his enthusiasm over the rapid development that the town was experiencing with this insightful observation: "Now, if our people would…pull together for another improvement that we must have, a good school system, the chances are Smyrna would grow rapidly." The correspondent understood that there was little prospect of Smyrna becoming a preferred suburb until it had first-rate public schools.

Smyrna at the turn of the twentieth century did not yet offer free, universal schooling. The State of Georgia as a whole, in fact, lagged well behind other parts of the nation in that regard. It was not until 1916, for example, that Georgia adopted a compulsory education act—the second to last state to do so. Only Mississippi was slower to act in that regard.

Public education has traditionally been a local responsibility. A Smyrna school board did exist, but its records, if any were kept, have disappeared. Such schools as existed in Smyrna at the turn of the twentieth century charged tuition and served white children only. Little money was furnished by either the county or by the town to support the local schools. Moreover,

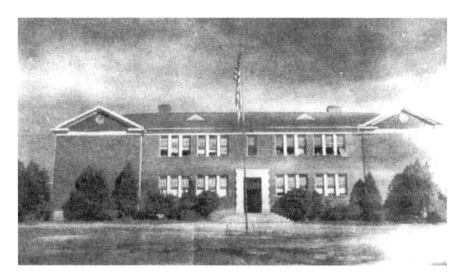

The Smyrna Elementary School on King Street, built in 1920, was destroyed by fire in 1924 but was almost immediately rebuilt. Its reconstruction was indicative of the town's growing commitment to quality public education. *Courtesy of Pete and Lillie Wood.*

parents who could afford to pay, as often as not, enrolled their children in the superior Marietta School System.

However, significant progress was made in the improvement of the town's schools in the third decade of the century, another indication of the community's mounting suburban aspirations. By 1920, the elementary division of the Smyrna Public Schools was comfortably ensconced in a $30,000 purpose-built structure on King Street, considered one of the finest elementary schools in Cobb County. When this building was gutted by fire in 1924, the people of Smyrna authorized a second $20,000 bond issue for its reconstruction, doing so by a commanding margin of 248 to 97 votes.

Had the Great Depression not intervened, the town would probably have moved quickly to provide itself with a modern high school as well. Smyrna High School, with its rather limited enrollment, was obliged to vacate its premises when the town sold the brick academy building to the Nelms Masonic Lodge in the mid-1920s, taking up residence thereafter in a succession of temporary locations. It was not until 1938 that Smyrna was provided with a small purpose-built high school building on King Street, situated next to the elementary school, a structure that was built by the depression-era Works Progress Administration.

As early as 1925, the state legislature offered financial incentives to encourage the consolidation of schools under county authority. By 1935, all

of the schools in Cobb County were administered by the County Department of Education, with the exception of the still independent Marietta and Acworth systems. The superintendent of the Cobb County Schools in the 1930s was a prominent Smyrna resident, attorney Francis T. Wills.

While the town of Smyrna was experiencing significant commercial and residential development in these years, the surrounding countryside remained a farming district. One elderly citizen told this writer that in the days of his youth (the 1930s), one had only to walk a few hundred yards east or west of the downtown to find oneself in a cornfield.

Cotton was still the engine of the Smyrna area's agricultural economy in the first decade of the twentieth century. But the following comment by the *Marietta Journal's* Smyrna column, appearing on April 4, 1906, foreshadowed the approaching collapse of the local cotton economy (emphasis mine): "Our farmer friends are getting ready to pitch their crop for 1906. Cotton will take the lead, of course, more cotton, better cotton, *and less money for it.*"

While agriculture continued to predominate in the countryside, the area's agricultural units were, in fact, undergoing a significant transformation. As late as 1900, half of Cobb County's farm acreage was still devoted to the wooly substance. The period after 1900, however, witnessed a gradual shift away from cotton toward a broader range of crops and, for the fortunate few who could afford improvements, a more scientific approach to the business of farming.

Many of the larger farms of the area were being subdivided in this period into smaller units. In 1919, for example, one of Smyrna's biggest landowning families, the Bowies, divided and sold off 380 acres of their extensive property, situated just south of the downtown.

Cotton growing was being supplemented increasingly in these years by crops for which a more reliable market existed, such as corn, orchard products, potatoes, wheat, oats, rye, alfalfa and clover. Several dairies existed in the Smyrna area as well, notably the Crowe family's Creatwood Dairy. The production of peaches and berries took on increased importance as well, leading to the establishment in 1908 of the Pearl Springs Cannery in downtown Smyrna.

The leading scientific farmers in the Smyrna area, known far and wide for their innovative practices, were Edward Wight, A. Loring Brown and J. Gid Morris, all of whom (at different times) owned and operated Belmont Farm, near the present-day intersection of Atlanta and Windy Hill Roads.

Loring Brown came to Smyrna in the late 1890s at the behest of Wight, the founder of Belmont Farm, forming a partnership with Wight. A 1912

biographical dictionary of leading Georgians credits Brown with having been "the best known farmer in Georgia." Another source noted that Brown was himself a kind of experiment station, and people from all over Georgia and other states made pilgrimages to witness his methods.

J. Gid Morris owned and operated Belmont Farm for many years after Edward L. Wight left the business. Brown established New Belmont Farm across Cherokee Street (now Windy Hill Road) from the original Belmont Farm following Wight's retirement. Both agricultural units produced a wide variety of crops on advanced principles in addition to raising poultry and cattle and producing dairy products. Brown and Morris won numerous state fair awards and prizes. In 1901, Morris brought another leading innovator, Henry Konigsmark, a poultry expert, from Iowa to help run the poultry division of Belmont Farm.

But most of the farms of the area were run on traditional principles. As late as 1930, two-thirds of South Cobb's farmers either rented their land or held acreage on a sharecropping basis. Tenancy was nearly universal among the area's black farmers, but even a majority of South Cobb's white farmers were tenants who lacked the resources to follow the examples set by scientific farmers like Wight, Brown and Morris.

This is not meant to imply that the Smyrna area was without some very sizeable farms—perhaps more appropriately described as plantations. Examples included the Carmichael property in the Log Cabin/Oakdale area, four miles south of the downtown; the Fleming property, just north of downtown (present-day Fleming Street crosses a portion of that property); the Simpson farm, situated some two miles east of downtown in the vicinity of the Bethel Baptist

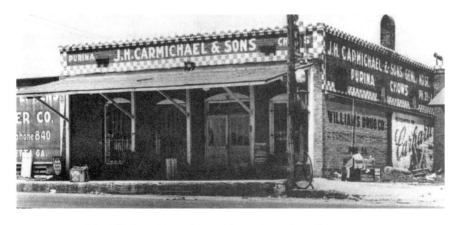

A 1915 view of the J.H. Carmichael General Store, situated at "Carmichael's Crossing" on the Interurban Trolley line, some four miles south of downtown Smyrna.

Henry Gautschy,
1864–circa 1940

One activity that supplemented the sometimes scant incomes of the area's farmers was the distilling of liquor from corn and other grains. Before 1907, the only large distilling operation near downtown Smyrna was the Chrystal Springs Distillery, owned by a Swiss-German immigrant named Henry Gautschy. The Crystal Springs Distillery stood near the present-day intersection of King Springs and Concord Roads, just beyond the western boundary of the town, on the site that later became the Baldwin Farm.

Henry and his wife, Rosa, immigrated to America in the late 1880s, settling in New York City. It isn't clear where Gautschy received his training as a distiller. He became a naturalized citizen in 1892, and it was probably some time in the late 1890s that the couple moved to Georgia.

The Gautschys did not reside at the distillery, which emitted powerful odors. They lived instead some miles to the south in the village of Gilmore, initially as boarders, but in 1902, they built themselves a house there. Gilmore lay midway between the Crystal Springs Distillery and the principal regional market for the liquor it produced: the fast-growing city of Atlanta.

Church; and the Petty property, a four-hundred-acre plantation that extended from the vicinity of present-day King Springs Road west along Concord Road. The owners of these larger agricultural units sometimes engaged in storekeeping as an adjunct to their farming operations.

When the market for cotton revived temporarily during World War I (1914–18), local farmers borrowed heavily to bring more land into production. Tractors and other mechanical devices were purchased by those with access to the necessary capital or credit. The federal government established a farm loan agency to encourage cotton growing, with its local headquarters in downtown Smyrna. However, when the war ended in November 1918, the demand for cotton went into free fall, leaving many of the area's cotton farmer's deeply in debt. With the coming to

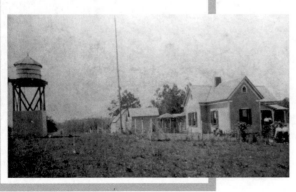

The Chrystal Springs Distillery, owned and operated by Henry Gautschy, stood near the corner of Concord and King Spring Roads. The distillery went out of business in 1908 when Georgia adopted prohibition. The property was later acquired by the Baldwin family who farmed the land for many years. *Courtesy of Michael Terry.*

North Georgia of the boll weevil infestation in the early 1920s, the cotton economy of the region received another rude shock, one from which it never recovered.

What of the area's black population? Black historian Rayford Logan famously described the period between 1877 and 1901 as the "nadir" of American race relations. That it may have been in the nation as a whole, but in Smyrna, the low point came a few years later, between the end of World War I and the late 1930s, and it was at least partially related to the process of suburbanization.

In the first federal census taken after the town's incorporation in 1880, 207 blacks resided in the Smyrna District out a total population of 786. Thus, in the first decade following the town's incorporation, blacks formed 26.0 percent of the population of the area as a whole. In

After the forced closing of their distillery in 1908 owing to statewide prohibition, the Gautschys moved to downtown Smyrna, where they constructed a distinctive German-style masonry residence, a structure that still stands on Atlanta Road, a short distance north of the Concord Road intersection. This unusual concrete block house is said to have attracted much attention while under construction.

Henry Gautschy tried his hand at storekeeping, without much success. Oral tradition tells us that the former liquor dealer and his wife were blackballed by the town's "respectable" element, especially those affiliated with the local Baptist and Methodist congregations, denominations that had long done battle with the liquor interests.

By 1910, the Gautschys had left the Jonquil City and were living in Florida, initially in Manatee, where Henry owned a shop that repaired engines, and later in Hillsborough, where he made his living as a druggist and grocery store proprietor, possibly again dispensing liquor. Henry Gautschy, seventy-six years of age and a widower, was still living in Florida in 1940.

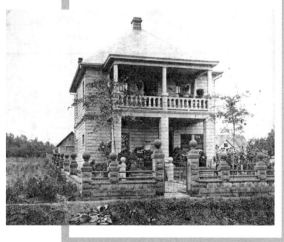

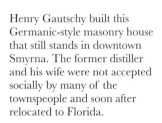

Henry Gautschy built this Germanic-style masonry house that still stands in downtown Smyrna. The former distiller and his wife were not accepted socially by many of the townspeople and soon after relocated to Florida.

The Mount Zion Baptist Church, dating from 1877, stood opposite the present New Smyrna Cemetery on Hawthorne Avenue in the Davenport Town community. The remains of an abandoned black cemetery mark the site today.

the town itself, however, blacks made up only 15.4 percent of the population. This disparity is easily explained. The vast majority of the area's employed blacks were farmhands who resided in the countryside. Significantly, in 1880, not one of the 61 blacks who labored in the fields owned the land on which he or she worked. These non-landowning farmers and farmhands, it should be noted, made up more than 90 percent of the area's black workers. The tiny nonagricultural element of the black community consisted of 3 house servants, 2 washerwomen and a blacksmith.

This lack of landownership, coupled with the group's high rate of illiteracy (more than 75 percent could not read), suggests that most blacks were living a hand-to-mouth existence.

Shortly after Smyrna's incorporation in 1872, a concentrated community of black households began to take shape in the vicinity of present-day Hawthorne and Davenport Streets just west of Smyrna Village, an area that prior to the 1897 boundary cutback lay within Smyrna. This community, which acquired the name Davenport Town, was thus subject in its early history to the authority of Smyrna's mayor and city council.

Davenport Town developed around a black church, the Mount Zion Baptist Church, founded in 1877. The name Davenport Town almost certainly stemmed from the presence of four Davenport households in that small neighborhood. The church stood just east of the present-day intersection of Hawthorne Avenue and Old Roswell Road, across from the New Smyrna Cemetery. In 1880, this small community contained about seventy residents residing in sixteen fairly contiguous households.

When Smyrna's boundaries were cut back in 1897, Davenport Town suddenly found itself outside the municipality. It seems likely that one of the objectives of the 1897 cutback was to "whiten" Smyrna by placing its

black residents outside of the town's boundaries, thereby making it a more desirable location for prospective white residents.

In many respects, conditions for black residents worsened after 1880. Not only did black landownership not increase to any appreciable degree, but onerous regulations were also imposed on this unfortunate population—the so-called Jim Crow system—making life still more difficult, conditions that prompted some blacks to quit the rural areas and migrate to urban centers, where employment opportunities were marginally better.

In 1920, at a time when the local black workforce numbered 115, a total of 65 (57 percent) of the area's employed blacks worked as farmers or farm laborers. Of the 31 identified as farmers in 1920, it should be noted, only 1 owned the land he cultivated.

Back in 1880, some blacks had voted. By 1920, virtually all of them had been deprived of that right. The adoption in 1908 of a new state constitution accelerated the process of disfranchisement by requiring that voters not only be able to read and write but also be able to interpret provisions of both the U.S. or Georgia Constitutions as a prerequisite to the franchise—or, alternately, that they possess at least forty acres of land or $500 worth of property, a requirement that no black resident of the Smyrna area was able to meet.

The Jim Crow system that arose in the South in the period between 1880 and 1920 imposed a litany of oppressive burdens on the area's black residents—laws against intermarriage and integrated schools; laws requiring the separation of the races on trains and streetcars; and laws mandating separate parks for whites and blacks (which translated into no parks whatever for blacks), separate water fountains, separate eating establishments, separate bathrooms, separation in theaters and meeting halls and even the use of separate bibles to swear on in courtrooms, as well as, of course, pervasive signage demarcating "colored" and "white" facilities, with the black facilities invariably inferior.

One of the worst features of this white-dominated social order was the blatant discrimination that existed within the criminal justice system. Blacks were excluded from juries, and their testimony was treated as suspect, with blacks far more likely to be charged with criminal acts and to be found guilty of the crimes of which they were accused.

This led to the arrest of large numbers of blacks on essentially trumped-up charges, with the labor of those convicted of crimes sold in many instances to white entrepreneurs who imposed a regime on these black convicts often more severe than the conditions that had existed under slavery. Historian

Douglas A. Blackmon labeled this system, in a recent study, "Slavery by Another Name." These oppressive practices put substantial sums into the pockets of leading businessmen, including, to cite but one notable example, Captain James English, former Atlanta mayor and owner of the Chattahoochee Brick Company, a concern that subjected black convicts to horrendous conditions in its Fulton County brickyards.

The intimidation of the black community by whites had its psychological as well as political and economic dimensions. While little is known of the activities of the local Ku Klux Klan (a secret organization), there is evidence of a vigorous Klan presence in Smyrna in these decades, as well as a high probability at the height of Klan power in the 1920s that Smyrna's leaders belonged to the secret order.

The Klan was apparently quite active in Smyrna. Stories have been told of local KKK members gathering in a lot on Sunset Avenue, possibly preparatory to one of their periodic marches through the area's black enclaves, processions calculated to strike fear into the hearts of the area's blacks. The daughter of a black Elizabeth Street resident, now nearly eighty, related to this writer her recollections as a small child of seeing local Klansmen marching through the Elizabeth Street/Railroad Alley black neighborhood in force in the 1930s.

Thus, one does not have to look far to explain the large-scale out-migration of blacks from Smyrna that occurred in the early years of the twentieth century. In the forty years after 1880, in fact, the area's black population was halved. While blacks had composed 26.0 percent of the Smyrna district's total population in 1880, by 1920, they represented a much smaller 13.4 percent.

Occasionally, accounts appeared in the *Marietta Journal*'s Smyrna column documenting the tense relationship that then existed between the races. One such story appeared on May, 30, 1918, during World War I, at a time when thousands of black men were serving their country overseas. The incident involved a group of black youths that demanded services from a local storekeeper—services that violated the social norms of a segregated society. The episode was reported under the headline, "Fresh Negroes Excite Smyrna Populace."

Smyrna's whites, the paper reported, "have been considerably excited because of certain presumptuous acts on the part of certain negroes of the vicinity. It seems that occasionally a negro has been sold an ice cream cone through the back door of the Wikle Drug Company and this probably prompted a party of negro men and women to march in the front door

of the store Sunday morning and ask to be served with fountain drinks. Dr. Westbrook was in charge of the store and naturally refused to serve the negroes and ordered them out. One of the men had to be put out."

The incident did not end there, however. That evening, as Dr. Westbrook was making his way home, he was waylaid by a party of blacks but escaped injury. Receiving word that another ambush was planned for the following evening, the pharmacist's friends escorted him to his residence. The offensive "negroes" were again waiting, the paper noted, but were beaten off a second time.

Later, one of the blacks, Otis Floyd, was arrested, shot in the leg and thrown into the county jail. The story concluded, "The sheriff and some of his deputies have been in Smyrna nearly every day since [and] report that things have quieted down somewhat and that the worst of the disturbance is over."

The efforts to drive blacks out of Smyrna took the form in 1927 of a city council ordinance stipulating that no black resident could live within two hundred yards of a white resident. The ordinance was explicit: "It is hereby enacted by the Mayor and the Council of the Town of Smyrna that the occupation of any house or houses on any street in the Town of Smyrna by colored occupants where white residents generally reside shall not be permitted."

The sponsors of this ordinance, incidentally, were two of the town's most respected citizens: Francis T. Wills, a lawyer, minister and a recently elected city councilman (Wills was later named superintendent of the Cobb County Schools), and Nathan Truman Durham, a member of the Smyrna School Committee. However, there is no evidence in the town records that this ordinance required enforcement, for Smyrna's blacks seemed to be relocating outside of the municipality of their own accord.

By 1930, the black population of the town of Smyrna, which had stood at 13.2 percent in 1920, had fallen to a mere 4.0 percent. Blacks were not abandoning the area entirely, but they were in many instances moving outside Smyrna's boundaries, chiefly into the Davenport Town neighborhood just outside the confines of Smyrna. Nor should it be assumed that the sponsors of this legislation desired a wholesale exodus of blacks from the general area, for many white families employed blacks in a variety of menial capacities. An analysis of the black workforce in 1920, for example, shows that while 65 of the 115 employed local blacks worked on the land, the remaining 50 (43 percent of the black workforce)—many of them women—worked for white families as servants (14), washerwomen (17), cooks (6) and day laborers (13).

White employers, it should be noted, sometimes established close and protective relationships with their black employees. There were a number of such special relationships, the most notable being that between Dr. James Newton Brawner, the founder of the Brawner Sanitorium, and a local black man, Edd Wallington, whom the doctor employed for many years as a groundskeeper and cook. So close and affectionate did this relationship become over the years that Dr. Brawner took the extraordinary step of commissioning a portrait of Wallington, which still hangs in the historic Taylor-Brawner House.

FEDERAL REDUX, 1930–1951

The process of suburbanization that marked the period between 1905 and 1930 was interrupted by the Great Depression. The economic paralysis of the Depression years (1930–40) was powerfully felt in all sectors of South Cobb's economy. Thousands of residents lost their jobs. Countless businesses went bankrupt. The value of the area's crops fell by an incredible 60 percent.

Indicative of the general economic decline was a reduction in the volume of freight being transported through the area by rail. Bill Kinney, editor of the *Smyrna Herald*, recollected of these years:

> *From the porch* [of my boyhood home in Marietta near the tracks], *you could see the NC & St. L. freight cars roll by, but few of them were carrying much. Most cars were occupied by raggedly dressed men who seemed to be going nowhere and were in no hurry to get there. They rode gondolas, they sat atop box cars, and when the railroad police got too nosy, they crept under the cars and rode the rods in a dangerous manner that said they didn't care much if they got chewed up by the wheels.*

Bess Terrell's diaries document in considerable detail how one Smyrna family was affected by the Depression. The Terrells were an upper-middle-class family by the standards of the period. Their Roswell Street house was valued at $4,000 in 1930—only thirty-one residences in Smyrna were more valuable at that time. They also owned a car, a truck and a forty-acre farm a few miles northeast of their home place. Carl Terrell, Bess's husband, an

Nebraska-born Bess Embree Terrell, who came to Smyrna in 1927 with her husband, Carl, and their two children, Robert and Helen, lived on Roswell Street near the downtown. Mrs. Terrell kept diaries between 1927 and 1942 that furnish an invaluable record of day-to-day life in Smyrna in that period. *Courtesy of Helen and Nancy McGee.*

electrician, had earned an ample income in the prosperous 1920s.

The couple set great store by education. They paid extra tuition so that their son, Robert, could attend Marietta High School. Attending school in Marietta also involved riding the interurban trolley, which imposed an additional modest financial burden on the family. After Robert's graduation in mid-1932, his sister, Helen, was enrolled there in turn, so these educational costs continued.

The Terrells were also voracious readers of newspapers, magazines and books. Bess and Helen borrowed books regularly from Marietta's Curtis Library (it was not until 1936 that Smyrna acquired a small library of its own). The family also owned a radio in a day when not every family did.

The impact of the Depression on the Terrell household was slow in coming, taking the form of a steadily diminishing demand for Carl's services as a salesman and installer of elevators, a line of work he had engaged in for fifteen years. By 1932, this principal source of family income had dried up. Only once in that entire year was Carl called on to do elevator work.

Thus, the Terrell household was obliged to find other ways to furnish itself with the necessities of life. By 1932, Carl was relying on odd jobs for what little income he was able to generate. He began spending more time at the family farm (along with his son, Robert), cutting wood and growing food to be sold, traded or consumed by the family. The exchange or bartering of goods and services with neighbors, it should be emphasized, was an important facet of Smyrna's Depression-era economy.

By 1932, the Terrells were keeping a cow as well as pigs and chickens on their home lot on Roswell Street and also planting a productive home garden there. The Terrell family was, in fact, tending two farm units simultaneously. Bess was largely responsible for the home-based activities.

The production of milk and butter was a particularly important feature of the family's domestic economy, as was the cultivation of fruit and vegetables. At one point, Bess noted that the family was generating about 20 percent of what it needed as a minimum weekly income from the production and sale of the milk and butter produced at home. The Terrells also raised chickens on their Roswell Street lot, which provided them with a reliable supply of broilers and eggs. Even in the depths of the Depression, their diet was ample.

Carl Terrell, who served as Smyrna town clerk for several years in the late 1930s and early 1940, as well as a city councilman in the early 1950s. *Courtesy of Helen and Nancy McGee.*

In the meantime, Carl was desperately trying to find government work. He threw himself into Marietta politician Horace Hamby's successful campaign for Cobb County commissioner of roads and revenues, but no job was immediately forthcoming. Carl also attended political meetings throughout the 1932–33 period in the hope of finding a government job of some kind. He was involved in another political campaign in September 1932 (the diary does not identify the candidate), but his man lost. Bess noted of this involvement, "Carl's man got beat in the race, so it looks like no job." In one of the last entries in the 1932 diary, Bess noted, "We sure are hoping he will get [a] police job."

Some time earlier, Bess had inherited a sum of money from her sister's estate in Nebraska, but the funds were slow in coming. When a portion of that inheritance (some $500) finally materialized in 1932, it was used to meet pressing needs: outfitting Robert with new clothing for his high school graduation and settling back taxes and mortgage payments on both the Roswell Street house and the Terrell family farm on Terrell Mill Road, a property that Carl and Bess had purchased from Carl's siblings in the flush period of the '20s along with some adjacent lots that the couple rented out. These lots were still generating a modest income in the early '30s. On February 27, 1932, Bess wrote, "Carl and I went up to the Bishops and rented my lots to them for $20."

Bess's contributions to the family economy were especially notable. She may not have been earning wages, but her efforts were absolutely critical to the family's well-being. She ran a highly efficient household and kept a close watch on family expenditures. She cooked, canned, sewed, quilted, raised chickens, milked, churned and sold and traded goods with her neighbors. When Carl was elected Smyrna city clerk in the early '40s, she assisted him by keeping the town records, handled his correspondence and made deposits of the money the town collected from licensing fees, often depositing these sums in a Marietta bank, for in that period Smyrna had no bank of its own. Interestingly, she often carried these sums of money to the bank by trolley.

Bess maintained a very active social life as well, much of it centered in her immediate neighborhood. She exchanged visits regularly with friends and neighbors. She also belonged to a women's social circle—a network of neighbors who met in one another's homes periodically—and was also quite active in Smyrna's First Baptist Church. Carl spent much time at the Nelms Masonic lodge downtown. He remained politically active and did eventually secure work with New Deal–era agencies.

The mayor of Smyrna during the depths of the Depression was Pomp Fowler Brinkley, a railroad conductor, sixty years of age at the time of his election, who resided on Love Street. Brinkley had previously served on the city council from 1926 to 1929. He held the office of mayor from 1931 to 1933 and was succeeded by Henry Arrington, who occupied the position from 1933 to 1938. It was Brinkley who donated to the town the land that is now Brinkley Park.

The scale of local government, which had expanded in the period between 1910 and 1930, was cut back drastically during Brinkley's mayoralty. Taxes were reduced by 10 percent, property owners facing particular difficulties were sometimes excused altogether from paying taxes and the city even held off from prosecuting those in arrears.

Economy measures were introduced to reduce the cost of government. Sixteen of Smyrna's streetlights were discontinued in the early 1930s, which was probably the town's entire contingent. The city cut costs wherever it could. When local businessmen petitioned for a night watchman to patrol the business district following a rash of burglaries, the town agreed to add a watchman, with the condition that the merchants pay most of his twenty-five-dollar-a-month salary.

It was during this period that the widening of Atlanta Road was first urged. The need to widen that already heavily congested two-lane roadway would become a recurrent theme in town politics over the next half century. The parking and traffic problem was particularly acute in

downtown Smyrna, but the goal was to widen this key artery all the way from Marietta to the Chattahoochee River. A meeting of Cobb County officials was convened in Smyrna in 1933, with Marietta mayor T.M. Brumby Jr. officiating. A public meeting followed, but the 1933 initiative proved unproductive.

Interestingly, the town government in this period believed that it had the authority to deny any person it chose the right to live on particular streets. In a January 11, 1933 council meeting, for example, one Floyd Holcombe, a white man of "disreputable reputation" (no specifics are provided), was forbidden from moving to Smyrna's Lee Street neighborhood, where a number of prominent families resided.

In 1933, Nathan Truman Durham, one of the sponsors of the 1927 housing segregation ordinance, petitioned the city to invoke the ordinance to evict blacks from the houses they occupied on Elizabeth Street. Durham cited his wife Lizzie's fragile emotional health as the reason for this petition. Lizzie Phagan Durham was the aunt of the unfortunate Mary Phagan, the thirteen-year-old girl who had been murdered in 1913 in an Atlanta pencil factory, leading to the arrest of Jewish merchant Leo Frank.

Frank was found guilty of the crime on highly questionable evidence in an emotionally charged trial tainted by anti-Semitism. When outgoing governor John Marshall Slaton, who questioned Frank's guilt, commuted the Jewish merchant's sentence to life imprisonment, a posse of prominent Marietta residents abducted Frank from the Milledgeville State Prison and transported him to Marietta, where he was lynched. The notorious trial and lynching of Leo Frank drew international attention and opprobrium.

In pressing for the enforcement of the 1927 Smyrna housing segregation ordinance, Durham claimed that his wife had been traumatized by the murder of her niece and thus found the presence of blacks in her neighborhood deeply disturbing. Property owner Claude Osburn explained that the houses he had built on Elizabeth Street had never been intended for blacks but that the sorry state of the economy had forced him to rent to them. He also claimed that the white residents of the neighborhood had initially raised no objection to his doing so.

There is, in fact, no indication in the town records that the 1927 housing segregation ordinance was ever systematically enforced, nor was it enforced to the letter in this instance. Instead, a compromise was worked out whereby Osburn agreed to evict the black tenant who lived closest to the Durhams, providing the remaining Elizabeth Street/Railroad Alley blacks were allowed to remain. Osburn also promised the mayor and council that he

would "open up a private street at his own expense for exit and entrance of negroes in that vicinity" so that the neighborhood's black residents would in the future have minimal contact with the white families of the area.

One month later, the town took another step calculated to discourage blacks from living in Smyrna: on a motion of Thomas L. Hamby, a well-to-do railroad executive who lived on Spring Street, Smyrna revoked a building permit that it had previously issued for the establishment of a black church on Elizabeth Street. These incidents are indicative of the high level of racial tension that prevailed in Smyrna in the Depression era.

With the inauguration of Franklin Delano Roosevelt as president in March 1933, a significant measure of federal relief began to flow into the Smyrna area. The Agricultural Adjustment Act of 1933 offered financial incentives to farmers to produce less, in the hope that a diminished supply would raise the market value of crops. Ruford Hayes Cobb of Smyrna, a local farmer, was elected to three consecutive terms as chairman of the Cobb County Agricultural Committee, which oversaw the implementation of this act. However, the program proved unpopular with many farmers, who resented being told how much they should produce.

Far more popular with the area's farmers was the work of the Rural Electrification Administration, an agency established in 1936 to provide federal loans for the installation of electrical distribution systems to serve rural areas. At the inception of the New Deal, 90 percent of American farms were without electricity. By 1938, over 170.2 miles of power lines had been installed under REA auspices in Cobb County alone, bringing electricity for the first time to some six hundred local farms.

The national unemployment rate stood at 25 percent when Roosevelt took office on March 4, 1933. The Depression was three and a half years old, and the agencies of government had made no real headway in solving the nation's chronic unemployment problem.

Two New Deal programs were initiated in 1933 and 1935 to deal with the unemployment issue. The short-lived Civil Works Administration (CWA), inaugurated in November 1933 and terminated the following March, spent an average of $200 million per month during its short lifespan and put some 4 million desperate Americans to work.

The CWA, in fact, provided Carl Terrell with his first regular job in nearly two years. In January 1934, the unemployed electrician was appointed a CWA district foreman and was placed in charge of supervising fifty men engaged in building the Bethel Road. Terrell received a salary of one dollar per hour for a thirty-hour week, plus an additional four dollars for the use of

The Smyrna Public Library was founded in 1936 as a collaborative effort of the New Deal's National Youth Administration and local civic organizations. It was housed during its first quarter century in a portion of the Smyrna Women's Club headquarters in the old downtown. Not until 1961 did Smyrna provide itself with a purpose-built library structure.

his truck. On January 1, 1934, Bess Terrell wrote in her diary, "We certainly have a brighter outlook this year than we did last January 1ˢᵗ."

Some of Smyrna's young men found work with the Civilian Conservation Corps (CCC), which maintained a camp at Kennesaw National Battlefield Park. The CCC did much to expand and improve that facility.

The CWA was replaced in 1934 by a more comprehensive government program, the Works Progress Administration (WPA), which launched tens of thousands of building projects all over the country in the next eight years. Its activities in Smyrna led to the installation of sidewalks, gutters and sewers. Pete Wood recalled that the WPA established a mattress factory in a building downtown to provide jobs for local women.

In 1936, the National Youth Administration (NYA), an arm of the WPA, assisted the Smyrna Women's Club and the Smyrna Men's Club in establishing a public library in the town. Schoolteacher Lena Mae Green was instrumental in the establishment of this important local institution. Mrs. Green had helped found the Smyrna Women's Club in 1927, serving as the first president of that highly active local social service organization. The club headquarters, located at the corner of Atlanta Road and Powder

Sprigs Street, housed the library's small but growing collection during its first quarter century of existence. By 1938, there were about 1,400 books on the library's shelves, and in the following year, the Smyrna Women's Club added a room to its clubhouse to accommodate this growing collection.

For many years, the salary of Smyrna's librarians was paid with a combination of federal funds and contributions from the Smyrna Women's and Men's Clubs. The town government provided no support for the library at this juncture.

The year 1938 witnessed the most serious outbreak of racial violence in the history of Smyrna, a riot that raged for two successive nights (October 17–18) and drew national attention to this small North Georgia community. As Cobb County historian Tom Scott wrote of this tragic incident, "This riot provide[s] a local example of the lengths to which the Caucasian majority would go to maintain white supremacy."

The riot was precipitated by the murder of a sixty-six-year-old white farmer, George Washington Camp, and his daughter, Christine Camp Pauls, as well as an attack on Mrs. Paul's nine-year-old son, Cecil. This brutal double murder and beating of a child was committed by an inebriated thirty-one-year-old black man, Willie Drew Russell, at the Camp farmhouse on Cooper Lake Road about three miles southwest of downtown Smyrna.

Camp, a relatively poor farmer, lived in a modest three-room farmhouse (described by the *Marietta Journal* as a "lonely farm shack"). He had apparently hired Russell as a laborer on more than one occasion and owed him some back wages, which Russell sought to collect. The two men argued heatedly outside the Camp farmhouse, whereupon Russell turned violent and bludgeoned Camp to death with an axe handle. Then he entered the house and did the same to Mrs. Pauls and also severely beat young Cecil, whom he left for dead. Several hours later, however, the boy regained consciousness, crawled to a nearby farmhouse and identified Russell as the perpetrator. Russell, who had in the meantime fled to Atlanta, was quickly apprehended and sent to the Fulton County Courthouse for safekeeping.

Once word got out of these killings, a mob, estimated at five hundred to seven hundred men, gathered to wreak vengeance on the blacks of the area. This frenzied mob rampaged through the streets of Davenport Town, where Russell and his wife then lived, stoning and chasing black residents into the surrounding woods.

The tumult was not, however, confined to the Davenport Town neighborhood. The rioters also stopped streetcars and automobiles on Atlanta Road and attacked black passengers indiscriminately. According to the account

This photo of the Smyrna Police Station reflects the scale of the depression period. In 1940, the police department was composed of only three officers.

that appeared in the *Marietta Journal* following the first night's rioting, "At least 15 Negroes were beaten or stoned...Members of the mob stopped the Atlanta-Marietta streetcar and walked down the aisle, flailing negro passengers with sticks." The local constabulary was far too small to suppress this violence, even if it had been of a mind and had the courage to do so.

It is unclear what role, if any, the local KKK played in this episode, but it is hard to believe, given its frequent threatening forays into Davenport Town, that the Klan was not a party to this rampage.

While no one was killed in these disturbances, the rioters did extensive physical damage to Davenport Town, burning down a newly constructed two-story schoolhouse for black children on Hawthorne Avenue, the Bethel School, which Cobb County had just opened on a lot adjacent to the Mount Zion Baptist Church. This two-room schoolhouse, staffed by two teachers and accommodating some seventy-five students, was the first schoolhouse for black residents ever erected in the Smyrna area.

The rioters also extensively damaged more than twenty houses in the Davenport Town neighborhood, at least eleven of which belonged to Claude Osburn, the developer who also rented to blacks on Elizabeth Street. Only when

Cobb County Courthouse, Marietta. It was here in the courtroom of Judge J. Harold Hawkins that Willie Russell, the murderer of George Washington Camps and his daughter, Christine Park Camps, was found guilty and sentenced to death by electrocution. This was also the site of the trial of the men accused of participating in the Smyrna Race Riot; only one of those arrested, Buck Miller, pleaded guilty, and he was sentenced to a one-year term at the state farm.

outside help came from the Cobb County Sheriff's Office and the Georgia State Patrol was the Smyrna Race Riot finally quelled, by which time much of the Davenport Town neighborhood was a shambles.

Some local whites are said to have lent assistance and protection to the area's endangered blacks. Nina Ruff Beshers, daughter of former mayor Martin Varner Ruff, is credited with having prevented her black tenants on Railroad Alley (a lane that ran from Atlanta Road across the W&A tracks to intersect with Elizabeth Street) from being attacked. It is difficult to fathom how Mrs. Beshers could possibly have dissuaded this enraged mob from attacking her property if the mob had consisted entirely of out-of-towners, as was alleged in the aftermath of the disturbance.

Willie Russell was quickly found guilty of the double murder and was electrocuted on December 9, 1938. Of greater interest than the trial of Russell, who confessed his guilt, was the court's handling of the case against the twenty-eight men arrested as rioters.

Many Smyrna residents, including Mayor John Corn and the entire Smyrna City Council, gave testimony at the trial of the rioters. However, only one of the accused men—an outsider, as it happens—was found guilty of participating, and this individual, who had confessed his guilt, was sentenced to a relatively mild one-year term at the state farm.

The attitude of the white community toward the 1938 Smyrna Race Riot offers important insights into the racial attitudes of the time. An editorial

appearing in the October 20, 1938 issue of the *Cobb County Times* contended, somewhat illogically, that whites, not blacks, had been the principal victims of the mêlée, since most of the property damaged in Davenport Town belonged to white landlords. The editorial also made much of the area's diminished reputation and sought to lay the entire responsibility on ignorant farm and mill hands who, it insisted, had converged on Smyrna from the surrounding countryside. The absence of any mention in this lengthy article of the local KKK, an organization well practiced in intimidating the area's blacks, is worthy of note.

That the Klan was still very active in Smyrna in the late 1930s is shown by a communication, dated March 5, 1938 (the year of the riot), and sent to the minister of the First Baptist Church, announcing that the Klan's local members, some fifty strong, planned to attend the congregation's March 27 evening service.

The 1938 Smyrna Race Riot and the unfavorable national attention it generated naturally discouraged the kind of suburban development that many of the town's political and business leaders were hoping would resume once the economy revived.

By the late 1930s and early 1940s, though, the economy was reviving. A facet of the late 1930s and early 1940s that had a singular developmental impact on Smyrna was the construction through the area of two new north–south highways, one lying to the east of downtown Smyrna and the other to the west. While the construction and subsequent development of these new arteries fostered Smyrna's economic growth it also diverted commercial activity away from downtown Smyrna. The first of these projects was the construction, in 1938, of the Cobb Parkway, the state's first four-lane highway, which lay two miles to the east of Atlanta Road. The other roadway, South Cobb Drive, which paralleled Atlanta Road to the west, was built in the period between 1942 and 1943 to facilitate access to the so-called Bell Bomber Plant.

As historian Joe Kirby has written of the impact of the Bell aircraft facility on the area, "In 1940, the site of the future plant was cotton fields and pines. By 1944, it was the largest factory in the southeast, providing 28,000 jobs. Those fields that had been plowed by mules and barefoot sharecroppers in 1940 were by 1944 churning out hundreds of copies of the world's most complex plane ever built to that point."

The story of the Bell Bomber Plant, and of its longer-lasting successor, the Lockheed Aircraft Plant, has been thoroughly recounted by Kirby and by Cobb County historian Tom Scott in their writings. Here we are chiefly

The Dickson Shopping Center, the first to be established in the Smyrna area, dating from 1946, stood at the southwest intersection of Concord Road and South Cobb Drive.

concerned with the impact that the coming of this giant industry, Georgia's largest industrial facility, had on Smyrna.

In the period between 1943 and 1960, South Cobb Drive and adjacent acreage became the developmental focal point in the Smyrna area, while Atlanta Road and downtown Smyrna declined in importance. Before the early 1950s, it should be noted, South Cobb Drive lay outside the municipal boundaries of Smyrna. Such development as occurred in that area was accordingly of little benefit to the municipality from a revenue-generating standpoint. Only with the gradual annexation in the 1950s and 1960s of the acreage through which this key transportation artery extended did Smyrna derive direct fiscal benefit.

Automobile ownership became virtually universal in the 1940s, and this rendered alternative means of travel less financially viable. The Interurban Trolley went out of business in 1947, and the railroad discontinued passenger service to Atlanta in 1949. Whereas at the turn of the century cotton had been king, by the 1940s, the automobile was the dominant economic reality. Smyrna's outmoded downtown commercial district withered under the assault of the motor vehicle. The shopping mall took its place.

The first of these malls to make its appearance was the relatively small Dickson Shopping Center, which stood at the intersection of two major local roadways, Concord Road and South Cobb Drive. Thomas L. Dickson, who hailed from Jefferson County, Georgia, where his father had been a longtime county commissioner, founded this pioneer venture just after World War II.

LORENA PACE PRUITT, 1898–1982

As Smyrna's first and only female mayor, Lorena Pace Pruitt served as the city's chief executive from 1945 to 1948, in the period between the closing of the Bell Bomber Plant and the opening of its replacement by the Lockheed Corporation in 1951. She was first elected to public office as a councilwoman in 1944 and was the first woman to serve the city in any elected capacity.

Lorena Pace Pruitt, Georgia's first female mayor, headed Smyrna's town government for three terms in the late 1940s.

The Pace family had long been active in the affairs of the town. Mrs. Pruitt was the third member of the Pace family to hold the office of mayor. In 1914, she married Joseph Reid Pruitt, an employee of the Georgia Railway and Power Company.

Mrs. Pruitt had considerable administrative experience when she assumed the position. After graduating from the State Normal School in Athens, Georgia, she directed the Georgia Training School for Delinquent Girls and then served for a time as superintendent of the Confederate Soldiers Home in Atlanta. Later, she managed one of the Bell Aircraft Corporation's large cafeterias.

Lorena Pruitt was elevated to the post of mayor in a special election following the 1945 resignation of J.Y. Wooten, a real estate dealer. She defeated former Smyrna mayor C. Mayes Hamby in this election and held the post of mayor until January 1948, at a time when the city's annual budget stood at about $25,000, and the mayor's salary was a mere $25 per month.

Mrs. Pruitt vigorously opposed the discontinuance of the Atlanta Northern Railway, which had provided trolley service to the town since 1905. In this she was unsuccessful, however. Trolley service was suspended on January 31, 1947.

Otherwise, her time in office was largely devoted to infrastructure and water improvement projects. She succeeded in tapping into Atlanta's water system when negotiations with Cobb County for an increased supply foundered. She made street paving a priority, as most of Smyrna's streets were still dirt roads when she took office. In all, fourteen more Smyrna streets were paved for the first time during her period of service.

Mrs. Pruitt declined to seek reelection in 1948. Her replacement was the flamboyant J.M. "Hoot" Gibson, a relentless proponent of development, who occupied the post for the next four years.

Lorena Pace Pruitt remained active in community affairs in the years that followed, serving as an officer of the Smyrna Women's Club and as president of the Federated Business and Professional Club, among other organizations.

"At that time," Dickson recollected in a 1987 newspaper interview, "there wasn't a supermarket anywhere that I know of where people pushed a buggy and waited on themselves. I built a shopping center after I built the supermarket. That was the first supermarket and shopping center as far as I know in the whole community, and it started off with five push buggies." The Dickson Shopping Center when fully developed contained nineteen stores, every one of which, its founder proudly recalled, was occupied by an independent merchant. The Dickson Shopping Mall proved highly successful, attracting customers from far and wide.

FEVERED DEVELOPMENT, 1951–1980

The impact of the coming of the aeronautics industry on Cobb County was little short of transformational. First Bell Bomber, in the 1942–45 period, and then Lockheed, a permanent presence since 1951, drew large numbers of new residents into this still largely rural area, introducing a considerable measure of ethnic, religious and cultural diversity to the area and altering the popular outlook on many issues.

Bell Bomber's impact was comparatively modest compared to Lockheed's. It did foster population growth—a 38.5 percent increase in the decade of the 1940s—but with the closing of the giant plant in late 1945, Smyrna's growth rate naturally subsided.

In the 1950s, however, in the aftermath of the coming to Cobb County of the Lockheed Corporation and in the context of mounting Cold War demands for military aircraft, Smyrna began experiencing the rapid population growth and territorial expansion that so indelibly marked the period between 1950 and 1970.

During the course of the 1950s, Smyrna's population rose from a modest 2,005 (the threshold, incidentally, for home mail delivery) to 10,157 residents, an incredible 507 percent increase in a single decade. Moreover, this pattern continued into the 1960s, when the city's population again doubled. By 1970, Smyrna contained 19,157 residents, ten times the number that had lived there two decades earlier, and already ranked as the second-largest municipality in Cobb County, a position it still holds.

Federal defense expenditures played a dominant role in the city's growth rate, a point that the *Smyrna Herald*, the town's first weekly newspaper, commented on on February 28, 1963. "A word from Washington can turn some communities' gloom into boom and vice versa," the *Herald* declared.

Smyrna also expanded territorially in these years. Its boundaries had not changed since 1897, when, as an economic measure, it voluntarily reduced its size to a modest 640 acres.

In 1951, according to the *Marietta Journal*, Smyrna's Mayor J.M. "Hoot" Gibson and the city council were readying a bill for submission to the Georgia General Assembly that would have expanded the city uniformly by another quarter mile. However, this bill was never submitted owing to the opposition of assembly members Fred Bentley and Harry Williams, both residents of Marietta. There was apparently no love lost between Smyrna's Mayor Gibson and these legislators. The colorful Gibson, who was something of a perennial candidate, had made a bid for a seat in the legislature in 1950, only to be defeated by Bentley and Williams—thus his strained relationship with the area's state legislators.

Nor were Smyrna's residents uniformly supportive of the quarter-mile annexation proposal. This became obvious when a petition opposing the measure, bearing the signatures of no fewer than 409 Smyrna residents, reached the legislature. The opposition, the *Marietta Journal* declared, stemmed from concern that an annexation such as was being proposed would obligate the city to provide services to the outlying areas without significantly expanding its tax base.

Because of this opposition (the legislature having final authority in such matters), Mayor Gibson and the city council announced that, in the future, Smyrna would take a piecemeal approach to annexation. It would rely on individual landowners (would-be developers) to petition the city for annexation and consider all such applications on a case-by-case basis with a primary view to its impact on the tax base.

This change of policy put developers in the driver's seat where annexation was concerned. It also ensured that annexed parcels would pay for themselves through increased tax receipts. The developers of housing tracts were, of course, eager to secure the broader range of services that city governments provided—such amenities as sewerage, street lighting, improved police and fire protection and garbage collection, services the county was ill-equipped to provide. Annexation by Smyrna, of course, would make development sites more saleable.

Another explanation for the change of strategy on annexation, this one offered by a former city councilman, is that the quarter-mile extension would

have brought the African American Davenport Town neighborhood into the city. The absorption of this black neighborhood did not comport with the suburban image that Smyrna's leaders were anxious to promote. In fact, by the 1950s, Smyrna's leaders often boasted that there were no blacks left in the city.

The piecemeal approach to annexation, it should be noted, helps explain the amoeba-like geographical shape that Smyrna assumed after 1950, a shape not only irregular in contour but one that also enclosed many pockets of unincorporated acreage.

The first major annexations that Smyrna made included the Bennett Woods subdivision, developed by the Bennett Realty Company of Atlanta (a thirty-acre tract north of Concord Road in the vicinity of Dunton and Medlin Streets), as well as the much larger development of the former Belmont Farm running west from the present Atlanta Road/Windy Hill Road intersection and named Lockheed Heights. To this day, many of the streets in the Lockheed Heights neighborhood bear southern California names (the Lockheed Corporation's main headquarters being in Burbank, California)—names such as Burbank, San Fernando, Ventura, Inglewood, Glendale and Linwood, which reflect the profound developmental impact that the Lockheed Corporation had on the city.

A second shopping mall—the Belmont Hills Shopping Center—was built as part of this giant project. The chief developer of this mall was Bill Ward, a prominent businessman. Back in 1941, Ward, then serving as president of

The Belmont Hills Shopping Center, located at the southeast intersection of Atlanta Road and Windy Hill Road, dating from 1954. When it opened for business, it was one of the largest shopping centers in the southeastern United States.

the American Bantam Car Company, had invented a new type of military vehicle, the Jeep. Ward moved to Cobb County soon after the war.

Bill Miles in his *Centennial History of Smyrna*, a booklet written to celebrate the town's 1972 100th birthday, traced the development of the Belmont Hills Shopping Center to a 1949 meeting between Ward, Mayor Gibson and Stuart Murray, the founder of the Atlanta Beverage Company who then owned Belmont Farm. A second, more detailed account of this meeting, written by journalist and local historian Bill Kinney on September 2, 1987, added three other men to this gathering—Smyrna realtor Paul Brown, plow magnate Clyde King, and Boston entrepreneur Wilson Lavender—noting that the participants "sketched out the [shopping] center on a brown sheet of meat wrapping paper from Murray's freezer over a bottle of Jack Daniel Black Label whiskey." Moreover, this group of developers did not stop with the Belmont Hills site. Among other Smyrna projects the men promoted, according to Kinney, were Cobb Heights and Concord Estates, both located off South Cobb Drive.

Ward remained a major Smyrna and Cobb County booster in the years that followed, famous for declaring, "You can't make a bad investment in Cobb County!" Smyrna's Ward Street was named for this important developer.

Ward attributed Smyrna's extraordinary growth potential to its ideal location between Atlanta and Marietta, allowing for "ease of egress and ingress to the heart of the metropolis," as well as the town's physical attractiveness. His optimism was such that Ward predicted that Smyrna would overtake Marietta in population by 1970.

In January 1952, the *Marietta Journal* reported that 542 houses were due to be built at the Lockheed Heights location, a development conveniently situated just off South Cobb Drive, providing prospective homeowners with ready access to the nearby Lockheed plant. These houses, the paper noted, would be well-constructed two- to three-bedroom structures costing an average of $8,000 to $10,000 apiece.

Annexation of surrounding territory continued apace. In the eleven-year period between 1959 and 1970, for example, Smyrna absorbed some 1,400 additional acres. In 1966 alone, 244 acres were added to the city. Annexations continued to be made with slight fluctuations in the years that followed, to the point that Smyrna is today almost fifteen times larger than it was in 1950.

Other factors besides Lockheed fueled Smyrna's growth. The city of Atlanta was expanding exponentially in the 1950s and 1960s, and urban

sprawl was spilling over into Smyrna to a degree. In addition, the phenomenon of "white flight" saw large numbers of Atlanta's white residents seeking refuge from accelerating racial desegregation in politically independent and majority white Smyrna.

These years also witnessed a continuing decline in the economic viability of Smyrna's downtown. According to a report commissioned by the city in the '50s, downtown Smyrna then contained forty-six businesses, including eight service stations, five laundries, three drugstores, three doctor's offices, two groceries, two barbershops, two real estate offices, two general stores, an army-navy store, a bank, a record store, a beauty parlor, a photographic studio, a radio and TV repair shop, a lawyer's office and a flower shop. In addition, various government buildings were situated there, including the city's first purpose-built city hall, a fire station, a police headquarters and an elementary school. While downtown Smyrna still exhibited a measure of commercial vitality in the 1950s, it was already suffering from problems that imperiled its future.

An August 8, 1963 article in the local paper summarized the amazing progress that Smyrna had made in recent years. It estimated the city's 1963 population at sixteen thousand and reported that the Jonquil City now contained six parks and six elementary schools, with two others "in the offing," and had acquired a new city library, built in 1961. Smyrna had experienced thirty-six annexations in the previous three years alone and had seen no fewer than seventeen subdivisions constructed in that short period of time.

But the problem of Atlanta Road had yet to be resolved. Before 1940, this thoroughfare had been the main north–south artery in Smyrna, but the construction first of Cobb Parkway in the late 1930s and then of South Cobb Drive in 1942-43 had robbed Atlanta Road of its primacy as Smyrna's chief transportation artery and was slowly sapping the economic vitality of the downtown area. With the opening of Cobb Parkway, Atlanta Road had, in fact, ceased to be part of the Dixie Highway (Route 41)—that designation shifting to the much newer four-lane thoroughfare. With the construction of the Cobb Parkway, the Atlanta Road tourist trade, one of the town's main industries since the 1920s, went into free fall.

The situation grew worse still with the construction of the Access Highway (South Cobb Drive). The acreage adjacent to this new roadway became the primary locus of both residential and commercial development in the general area. Acreage adjacent to South Cobb Drive was selling for much less than the land that flanked the more highly developed and semi-industrial

Atlanta Road. The existence of a railroad on the east side of Atlanta Road made the area less desirable for residential development. South Cobb Drive, on the other hand, presented no such problem. The acreage adjacent to South Cobb Drive was relatively inexpensive. In the early 1940s, when that roadway was first laid out, land in that area was selling for as little as sixteen dollars per acre.

As development came to the South Cobb Drive area, property values, of course, greatly appreciated. On July 4, 1963, the *Smyrna Herald* reported that the new Cobb County Center, which included a branch of Rich's Department Store, had led to a "doubling, tripling, and even quadrupling" of land values. "[T]he grab for land around the center [had thus] reached fever pitch."

The failure of the city and its leadership to make much-needed improvements to Atlanta Road and to modernize the downtown reflected a reluctance on the part of influential developers and their political allies in city, county and state governments to invest public and private resources in the improvement of a transportation artery that might compete with fast-developing South Cobb Drive—to avoid, for the moment at least, measures that might detract from the commercial and residential boom that the South Cobb Drive artery was experiencing. Smyrna's 1951 decision on annexation had given the initiative to a group of developers that was now pressuring the powers that be to invest public moneys in the newer roadway in preference to the older artery.

This was made plain in July 1965 when the state suddenly announced that it was designating South Cobb Drive a "primary" roadway while demoting Atlanta Road to "secondary" status. The State Department of Transportation also threw its support behind the movement to make the entire length of South Cobb Drive a four-lane highway. The *Smyrna Herald* noted of this development, "South Cobb presently has four lanes near Lockheed but tapers into two lanes" farther south. The acquisition of the needed right-of-way, it added, would be far more economical here than on Atlanta Road because the newer thoroughfare had been carved out of a densely wooded area where rights-of-way could be more economically procured. Moreover, "as a primary road the financial burden of construction falls on the state and federal government, while old US 41 [Atlanta Road], demoted to secondary status, would be dependent upon the county for acquisitions of the needed rights of way."

While the town was experiencing both rapid development and expansion of its boundaries on an unprecedented scale, the city's

The small scale of most of the buildings in Smyrna's old downtown is clearly evident in this view of the west side of the commercial strip.

deteriorating downtown, where the vacancy rate by 1960 had already reached 10 percent, stuck out like a sore thumb. "The two block area on North Atlanta Road in the heart of the city is [Smyrna's] only old portion," the *Smyrna Herald* declared in 1960. Other than the downtown area, the paper asserted, Smyrna contained "no substandard real estate."

The paper went on to note that only one new building stood in the downtown: a structure that served as the paper's own headquarters. The rest of the commercial district's physical plant was outmoded.

Thus, additional downtown development and the improvement of existing downtown facilities were blocked by a host of factors. While the area remained convenient for residents of adjacent streets, the heavy reliance that Smyrna's residents now placed on automobiles and the lack of adequate parking in the commercial district gravitated against additional development there.

The mile-long portion of Atlanta Road running through the downtown was too narrow to handle rush-hour traffic, while the railroad tracks on its eastern edge impeded commercial expansion in that direction, despite zoning calculated to encourage such development along East Spring and Roswell Streets. The residential district lying east of Atlanta Road downtown

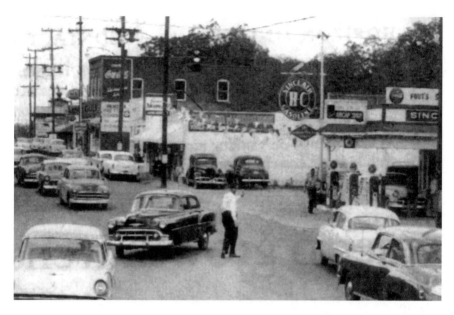

Here we see the east side of downtown Smyrna as it appeared in 1957. The large two-story brick building at the center of the photo is the former Whitfield grocery store. This portion of the downtown, which backed up to the railroad, was the first part of the downtown demolished in the late 1980s as part of the downtown redevelopment project.

(the present-day Williams Park neighborhood) was considered to be on "the wrong side of the tracks."

We have already mentioned how the Dickson Mall, built in 1946, and the Belmont Hill Mall, dating from 1954, vitiated the commercial vitality of the downtown. In 1959, a smaller mall, Jonquil Plaza, was built at the southern end of the downtown area in an attempt to reverse this decline. Jonquil Plaza provided much-needed parking, and some downtown merchants relocated there, but this attempt to reconfigure Smyrna's downtown was at best a stopgap measure.

The traffic problem stemmed not only from the narrowness of Atlanta Road but also from the additional problem that motorists were accessing the four-lane Cobb Parkway, the principal road into Atlanta, by way of East Spring and Roswell Streets. An incredible ten thousand vehicles utilized these streets on a daily basis, generating rush-hour traffic jams that contributed to congestion in the downtown and also discouraged residential development on the east side of Atlanta Road.

Delays at the East Spring Street and Hawthorne Avenue railroad crossings complicated an already bad traffic situation. As of the mid-1960s, the

Hawthorne Avenue railroad crossing had no signals. As the *Smyrna Herald* noted on July 22, 1965, "Efforts by the city to get a signal erected have floundered in the past in spite of several train-car accidents at the heavily traveled crossing point." The paper described the situation at Hawthorne Avenue as "Smyrna's major traffic hazard."

In late 1962, two nearly fatal accidents occurred at the Hawthorne Avenue location. One of these involved J.B. "Jake" Ables, a future Smyrna mayor, who sued the railroad and collected $7,500 in damages. Bakery truck owner Floyd O. Moore likewise brought suit when a train rammed his truck. Moore charged that the train had neither sounded a whistle before reaching the Hawthorne Avenue crossing nor reduced its speed. This dangerous crossing point also posed a serious hazard for children walking to the nearby Hawthorne Elementary School.

All of these conditions—traffic congestion, a dearth of parking on Atlanta Road, the problems posed at railroad crossing points and the downtown area's seriously outmoded physical plant—hindered significant improvement of the city's principal commercial district and discouraged the construction of quality residential development along nearby streets.

Some improvement came in 1965 with the building over the W&A tracks of an overpass extending from Atlanta Road, opposite the present Concord Road intersection, to Spring Road. The city's voters approved the bond issue for this overpass by a vote of 566 to 127. The total cost was a substantial $1.25 million. This Spring Road overpass eliminated the traffic problems that had so long plagued the East Spring/Roswell Street neighborhood, but it did not solve the problem of a deteriorating commercial district. Not for another quarter century would the agencies of government confront that problem head on.

The opening of the Cobb County Center on South Cobb Drive in 1963 drove another nail into the coffin of Smyrna's deteriorating downtown. This giant mall provided shoppers with some fifty additional stores, including a branch of Rich's Department Store, Atlanta's principal shopping mecca.

Another major dilemma of the period was the challenge posed by racial integration of Cobb County's schools. In 1954, the U.S. Supreme Court handed down its landmark *Brown v. Board of Education* decision mandating integration of the nation's public schools "with all deliberate speed."

In Georgia, as in all of the southern states, the *Brown* decision met strong resistance. A succession of Georgia governors—Herman Talmadge (1948–55), Marvin Griffin (1955–59) and Samuel Vandiver (1959–63)—railed against school integration and did all that they could to obstruct compliance. At Governor Talmadge's urging, the Georgia legislature passed a constitutional

James Vinson Carmichael, 1910–1972

James Vinson Carmichael was arguably the most important political and business leader to emerge from the Smyrna area. His parents, John Vinson Carmichael and Emma May Nolan, owned a large farm and country store in the Log Cabin community a few miles south of Smyrna.

Just before James's sixteenth birthday, he was hit by a car while running across the Dixie Highway to catch a trolley to Marietta, where he was then attending high school. The car dragged the boy over one hundred feet and almost completely severed his spinal cord. James required a year's recuperation before he could return to school and was thereafter confined to a wheelchair. In time, he learned to walk short distances with a cane, but he endured intense pain for the rest of his life.

However, Jimmy Carmichael's disability did not stop him from completing his education and pursuing a highly successful career in the law, public service and business. Carmichael graduated from Emory University with a law degree in 1933. He then moved to Marietta, where he founded a highly successful law firm with his high school friend Leon M. "Rip" Blair, the longtime mayor of Marietta (1938–47).

Carmichael's subsequent career included service as city attorney of both Smyrna

Here we see Cobb County attorney James Vinson Carmichael (second from the left) with World War I fighter ace Eddie Rickenbacker (then president of Eastern Airlines), Marietta mayor Rip Blair and Cobb County commissioner George Macmillan in the early 1940s at the site of Cobb County's future airport, Rickenbacker Field (now Dobbins Air Force Base).

(from 1934 to 1938) and Marietta, and as Cobb County attorney. In the late 1930s, he chaired a committee established to work with New Deal agencies to improve Smyrna's sewerage system. He also served in the Georgia General Assembly for two terms in the late 1930s, elected in both instances without opposition. In 1938, Carmichael married Frances Elizabeth McDonald, with whom he had three children.

Carmichael's most important contribution to the development of Smyrna was the central role he played in bringing first the Bell Bomber Plant to Marietta during World War II and then Lockheed to the same locale in 1951, thus laying the foundation of the state's aeronautics industry.

The initiative for the industrial development of Cobb County began in 1941 when Carmichael joined his friend "Rip" Blair and Cobb County commissioner George McMillan in establishing an airport in Cobb County, originally called Rickenbacker Field and later renamed Dobbins Air Reserve Base.

Carmichael served for a time as general manager first of the Bell Bomber plant and then of the Lockheed plant. He played an active role over the years in fostering industrial development throughout the region. In 1947, during the hiatus between the closing of the Bell Bomber Plant and the coming of Lockheed, Carmichael assumed the presidency of Atlanta's Scripto Pen Company. Under his leadership, Scripto became the largest manufacturer of writing instruments in the world.

In 1946, Carmichael was very nearly elected governor of Georgia, running as a progressive Democrat against former governor Eugene Talmadge. Although Carmichael received more popular votes than Talmadge, the county unit system, which weighted elections in favor of Georgia's rural counties (an electoral system later ruled unconstitutional) gave the victory to Talmadge.

Carmichael was throughout his career a strong supporter of educational reform, and while calling himself a segregationist (a prerequisite for election to office in Georgia in those years), he was considered moderate on racial issues.

A building on the campus of Kennesaw State University, named in his memory, testifies to Carmichael's support of education. It strikes this writer as ironic, given his contributions to improved education, that no public school in Cobb County yet bears Carmichael's name. Carmichael was also a strong supporter of the arts and helped found Atlanta's High Museum.

When Jimmy Carmichael died in 1972 at the relatively young age of sixty-two, Dan Haughton, chairman of the Board of the Lockheed Corporation, declared, "We have all lost a great leader in the aerospace industry, in general, government, law and the arts. The state of Georgia and the United States have lost one of their greatest sons."

amendment that authorized the state to close down its public schools and offer tuition vouchers that would enable students to attend private, segregated facilities. When the required referendum was held on the issue, it passed in Georgia as a whole, but a majority in Cobb County residents voted against the proposal.

The first major local initiative stemming from the *Brown* decision, calculated to reconcile the Davenport community to continued segregation, came in 1958 when Cobb County replaced its outmoded black school in that neighborhood with a modern (though still segregated) facility: the Rose Garden Hills Elementary School. The Rose Garden Hills neighborhood had been developed earlier in the decade, with Federal Housing Authority support, as a quality segregated community for blacks. It advertised itself as "Georgia's finest Negro subdivision."

In a 2011 article entitled "Desegregating Cobb," journalist Todd Hudson wrote that the majority of Cobb County's residents were simply unwilling to jettison public education to perpetuate segregation. While white residents feared the consequences of integration, the majority was, by the same token, unwilling to join such groups as the Ku Klux Klan and the Cobb County White Citizens for Segregation in urging a boycott of businesses that would not actively oppose integration.

Joe Kirby, in his history of the Lockheed plant, put his finger on a key factor shaping the attitudes of the people of Cobb County toward their public schools:

> *The* [Lockheed] *plant's presence has had an...impact on the local educational establishment. The need for thousands of workers with the kind of better-than-average intelligence needed to assemble Lockheed's planes proved a continuing impetus for Cobb schools...to steadily improve. The plant brought to Cobb thousands of engineers and managerial personnel from other parts of the country in its early decades who helped give the community a more cosmopolitan, forward-looking outlook than most of its peers around the Southeast.*

Moreover, the Lockheed Corporation, the engine of the local economy, had already taken steps to integrate its own workforce.

While implementation of desegregation in Cobb County took more than a decade, on March 1, 1965, the Cobb County Board of Education voted five to one in favor of desegregation. Actual implementation was phased in without incident over the following five years. On balance, desegregation in Cobb County was accomplished more easily than in most areas of Georgia.

'God Bless Our Happy City Council'

This political cartoon, which appeared on the pages of the *Smyrna Herald* in the early 1970s, underscores the contentiousness that prevailed in Smyrna's City government in those years.

As compared to the previous two decades of spectacular growth, the decade of the 1970s was one of relative stagnancy. This is readily apparent in the federal census figures that appeared in 1980, showing that Smyrna had registered the lowest population increase of its history in the 1970s—a gain of only 1,162 residents (a mere 6 percent). This extremely slow rate of growth stemmed from a host of factors, national as well as local: the

winding down of the Vietnam War, the Middle Eastern oil embargo and a combination of high inflation and high unemployment (a phenomenon labeled "stagflation").

Most significantly, from the local standpoint, was a reduction in the demand for military aircraft. Lockheed's workforce shrank by an incredible 75 percent between 1969 and 1977, a decline from an all-time high of 33,000 workers to a mere 8,400 in that eight-year period. All of this, of course, meant fewer annexations and a slowing rate of development for Smyrna.

Despite this marked national economic slowdown and the reduction of the Lockheed workforce, Smyrna's tax receipts actually made modest gains in these years, and public improvements continued: Smyrna City Hall was remodeled and expanded; the city opened two new fire stations; the largest of Smyrna's parks, the twenty-six-acre Tolleson Park, was dedicated; a city zoning board and a parks and recreation board were instituted; and Smyrna's city ordinances were for the first time codified and published in book form.

The mayors and councilmen who served in the '70s were, in fact, so confident in Smyrna's long-range prospects that they authorized budget increases in every fiscal year of the decade, doing so without once raising the millage rate. At the beginning of this decade, during the mayoralty of Harold Smith, the city's budget stood at a bit under $1 million. By 1979–80, with Frank Johnson as chief executive, Smyrna's budget had risen to an impressive $5.6 million, despite its slower rate of population increase.

The 1970s were also a period of rising political contentiousness in Smyrna. Bill Kinney, *Marietta Journal* editor, described the Jonquil City in an August 3, 1977 article as "long Cobb County's hottest political battlefield." This had been true since the 1950s, when the colorful J.M. "Hoot" Gibson entered the political lists to take on what he referred to disparagingly as the "Ables-Kreeger" crowd.

With the unexpected defeat in the 1969 mayoral race of two-term mayor George Kreeger (a gruff personality who would sometimes tell complaining constituents to "shut up and be quiet") by relative newcomer Harold Smith, political daggers were drawn. Kreeger's allies and the many aspirants to the office of mayor (several serving on the council) turned city hall into a political battlefield, as the *Smyrna Herald* cartoon in this chapter attests.

Smith was defeated in his 1971 bid for reelection by fellow councilman John Porterfield, who held the office from 1972 to 1975. The major controversy of Porterfield's time in office stemmed from his refusal to remove longtime police chief and political ally Robert L. Drake. Porterfield was succeeded, in turn, by Arthur Bacon, who proved quite popular but

who decided not to seek reelection for health reasons. His decision to step down may also have been prompted by the keen disappointment he felt at the city's failure to make progress on the widening of Atlanta Road, a project he had declared his number one goal.

Bacon was succeeded by Frank Johnson, a Georgia Power executive who served two terms in the office. The 1977 mayoral race saw two other candidates contending for the office, both former councilmen: Marston Tuck and Forster Puffe. Although an issue was made of his employment with Georgia Power (seen as a potential conflict of interest), Johnson prevailed.

Interestingly, Forster Puffe was dismissed as a serious contender in 1977 by astute political observer Bill Kinney because of his northern origins. Anti-Yankee sentiment was still strong in Smyrna at the time. "Personally, I like Forster and find him to be an intelligent and personable citizen," Kinney wrote. "But many old timers say Smyrna isn't ready for what they call an outspoken Connecticut Yankee with a handle bar–like mustache." One doubts that the same political calculus holds today, with so many more so-called Yankees living in Smyrna, but in the 1970s, anti-northern sentiment was still very much a political reality.

SMYRNA REINVENTED, 1980–2013

C onceived by its founders as a potential commuter suburb, Smyrna in the century that followed its 1872 incorporation only partially fulfilled that ambitious vision. Progress had been made intermittently, as we have seen, but a series of obstacles slowed or blocked the suburbanizing process. In the period between 1980 and 2000, however, the Jonquil City finally achieved the goal of its founders and emerged as one of Metropolitan Atlanta's premier suburbs.

This transformation coincided with the administrations of two particularly forceful mayors—Arthur Bacon (who served from 1976 to 1977 and again from 1982 to 1985) and his son, Max, who succeeded to the mayoralty when Arthur succumbed to lung cancer in 1985.

Max Bacon has held the office of mayor continuously for the past twenty-eight years and is thus not only the longest-serving mayor in Smyrna's history but also the longest-serving head of a municipality in the southeastern United States. "Mad Max," as his detractors sometimes called this energetic young mayor in the early years, presided over and largely orchestrated a fundamental transformation of Smyrna that has drawn national attention and plaudits.

The first of the Bacon mayors, Arthur, was a World War II hero and a local realtor. He was born in the town of Stevens in northeastern Georgia in 1917. His father, Robert H. Bacon, having been hired as a car inspector by the NC&StL Railroad, moved his family to Smyrna when Arthur was a small child, settling on Roswell Street near the Smyrna Depot.

Arthur Bacon and his wife, Dorothy Moseley Bacon. Arthur served three terms as mayor and accomplished much for the city. *Courtesy of Max Bacon.*

Arthur's was a typical Depression-era childhood. He recollected selling jonquils to tourists who passed through the town in the 1920s on their way to Florida. He was also a highly talented athlete.

Arthur attended Marietta High School, where he won an athletic scholarship to Oglethorpe University, but with the outbreak of World War II, he interrupted his studies to join the military. He came home from the war as a decorated hero, having participated in many of its key engagements, including the Battle of the Bulge. Remaining in the reserves for some years, he also saw service in the Korean Conflict, finally retiring from the military in 1958 at age forty-one with the rank of captain.

Bacon subsequently worked as a rural mail carrier. For a time, he operated a dry cleaning business with his brother but eventually established a successful real estate business. In 1946, he married Dorothy Moseley of Sumter, South Carolina, a former army nurse, and the newly married couple built a house on Bank Street, where Arthur lived for the balance of his life and where his widow still resides.

Arthur Bacon served as an elected member of the Cobb County Zoning Board in the early 1970s. He then sought election to the Smyrna City Council and was defeated on his first try, but he eventually secured a seat, which he held from 1970 to 1975. In 1976, Bacon succeeded John Porterfield as mayor, but after serving a single term, he relinquished the office for health reasons and sat out the four years of Frank Johnson's mayoralty.

In 1981, having regained his health, Arthur Bacon again sought the mayoralty and was easily reelected, serving an additional two terms in the office (1982–85) but dying on October 26, 1985, at age sixty-eight, in the final weeks of his third term.

Bacon's main accomplishments during his second stint as mayor were significant. They included placing Smyrna's fire and police departments on a more professional basis; balancing the city's budget; selling revenue bonds that allowed the city to modernize its outmoded water and sewer lines and to upgrade its public safety and public works departments; expanding the city's boundaries and tax base through judicious annexations; overseeing the construction of Village Parkway, which fostered quality development in the northeast section of Smyrna; and establishing a public golf course on Windy Hill Road on land that the federal government ceded to the municipality.

Perhaps the most important of Arthur Bacon's accomplishments was his success in instilling more of a team spirit on Smyrna's contentious city council. This was no easy task. Arthur Bacon's ability to mold the formerly combative city council into a working team was cited by just about all of his colleagues in the aftermath of his death. He encouraged council members to involve themselves in as many projects as the city was involved in. This spirit of common endeavor would continue to be a hallmark of Smyrna's government in the post-1985 period under his son, Max.

Max Bacon, who succeeded his father as mayor by vote of the city council in November 1985, was born in 1948, the second child and oldest son of Arthur and Dot Bacon. He attended Smyrna Elementary School, and after graduating from Campbell High School in 1966, he went on to DeKalb College and Chattahoochee Technical College, followed by service from 1966 to 1970 in the Georgia Air National Guard.

Max Bacon was first elected a member of the Smyrna City Council in 1979, during Frank Johnson's mayoralty, two years before his father's election as mayor for the second time. He

Mayor Max Bacon, who succeeded his father in 1985, has presided over the affairs of the city for the past twenty-eight years, guiding its transformation into the preferred suburb of our time.

represented Ward 2, which included the Campbell Road area and other older sections of town, neighborhoods that the new councilman described as "neglected." In his six years as a member, he was arguably the most proactive councilman, speaking out forcefully on a broad range of city as well as county issues.

Smyrna's mayoralty is a part-time job offering relatively meager compensation. On that account, the city's mayors have been obliged to have independent sources of income. Arthur Bacon was a realtor. Max was the postmaster for many years of Mableton, Georgia, a position from which he only recently retired.

With the increase in the city's population from a mere two thousand in 1950 to thirty-five thousand by the mid-'80s, the job of governing Smyrna had become too complex and time-consuming for the traditional cadre of elected and appointed officials to handle. Thus, in May 1985, in the last months of Arthur Bacon's administration, the mayor and council established the position of city administrator to oversee Smyrna's increasingly complex day-to-day operations. John Patterson, an experienced administrator, was appointed to the new post, a position he held through the first phase of the downtown renewal project. Five other city administrators have occupied the position in the years since. Still, the principal source of authority and of policy initiatives in Smyrna rests with the mayor and city council.

Max Bacon succeeded his father as mayor on November 18, 1985, three weeks after Arthur Bacon's passing, by unanimous vote of the city council. Other candidates were mentioned at the time, but none chose to challenge Bacon.

The new mayor was confident that Smyrna would continue experiencing rapid development, given its location astride the so-called Platinum Triangle, the area in which the Galleria and Cumberland Malls are situated (an area containing more office space than downtown Atlanta). While the Platinum Triangle is situated outside of Smyrna, this rapidly expanding commercial zone naturally fostered significant development in the Jonquil City.

Another factor that encouraged Smyrna's growth was the pro-development climate that prevailed in the city. Taxes were kept low, and the process of obtaining approval for development projects was relatively uncomplicated. Thus, Smyrna fostered a pro-business climate.

In addition to encouraging continued growth, the new mayor announced the additional goal of generating the kind of growth that would enhance the quality of life of Smyrna's residents. In 1985, just before assuming the office of mayor, Bacon noted of this challenge, "In 1979 we approved $7 million

in building permits. Last year [1985] we approved $70 million." He then added a cautionary note: "With that kind of growth we have to be careful."

While Marietta remained the largest Cobb County municipality, containing nearly forty thousand residents, Smyrna was rapidly catching up. The Jonquil City was already the most densely populated municipality in Cobb County, and with density, the mayor realized, comes problems and challenges. In 1985, a majority of Smyrna's residents were living in apartments.

As late as the 1950s, there had been only one small apartment complex in the entire city. Much of the development in these years took the form of apartments, and some of the older complexes (most owned by absentee landlords), were by the mid-1980s in a state of advanced deterioration. Mayor Bacon believed that the city had to take a more aggressive approach to annexations if it was to realize its fullest potential. This required keeping rapidly expanding Marietta from absorbing unincorporated acreage that Smyrna might more appropriately annex and also preventing Cobb County from blocking annexations as a way of preserving its eroding tax base. The county considered various stratagems to slow down or completely eliminate further annexations. One such proposal called for the creation of a sixth Cobb County municipality—to be called Cobb—that would encompass all of the county's remaining unincorporated land and thus eliminate altogether further annexations.

Max Bacon vigorously opposed these schemes, and Smyrna continued annexing territory. In 1987 alone, the city absorbed an additional 453 acres. In the period between 1980 and 1987, it annexed some 2,419 acres, an area equivalent to one-third of its current size.

The mayor also supported the movement to absorb the portion of the heavily black Davenport Town–Rose Garden Hills neighborhood that still lay outside of Smyrna's boundaries. Much of the black enclave had been annexed in 1983 during Arthur Bacon's administration. In annexing the Davenport Town–Rose Garden Hills neighborhood, the city reversed a policy it had laid down in 1969 by unanimous vote of the city council stating that Smyrna would not, under any circumstances, annex any part of Davenport Town or Rose Garden Hills or consider extending city services into that enclave, notwithstanding the fact that the neighborhood was already completely surrounded by the city.

A small part of this black neighborhood that had not been absorbed in 1983, referred as "the Hole," had in the meantime developed serious drug and crime problems that Cobb County was unable to effectively police.

When the residents of the area, led by Reverend James Hearst, pastor of the Mount Zion Baptist Church, petitioned the city to absorb this area in 1993, Mayor Bacon and the council readily agreed. The city's annexation of this crime-infested area was indicative of two important trends: an improved relationship between the races and a concern that the city's suburban image not be tainted by unregulated criminal activities.

A shift toward the construction of free-standing owner-occupied residential units was one of the city's principal goals in these years. Smyrna adopted a temporary ban on the construction of apartment buildings in October 1993 after a study by Cobb County showed that the Jonquil City had become the county's most densely populated municipality and that more than two-thirds of the housing stock in the combined Smyrna-Vinings-Cumberland area were apartments.

However, the most important measures taken to effect the "reinvention" of Smyrna were the widening, at long last, of Atlanta Road and the closely related demolition of the old downtown, followed by the building over the course of the 1990s of a complex of state-of-the-art municipal and commercial structures along the western side of what had formerly been the old downtown.

The widening of Atlanta Road was completed in June 1987 at a cost of $3.2 million, covering the purchase of rights-of-way, as well as utility relocation costs, with the state picking up the tab for engineering and construction. But that was only a first step.

Downtown Smyrna, as we have seen, had been in decline for a quarter century. The buildings in the commercial strip were small, cramped, poorly heated and poorly lit, and downtown business establishments were losing patronage. A number of these outmoded downtown structures had been converted into antique shops, in itself a sign of commercial decline.

The first step in the demolition of the old downtown involved the removal of the buildings along the east side of Atlanta Road, buildings that backed up to the tracks of the old W&A line. This initial step in the demolition of downtown Smyrna was carried out in the fall of 1987 and aroused little opposition. Nor was there significant opposition to the subsequent demolition of commercial structures along the western side of Atlanta Road on a piecemeal basis over the next two years. A group calling itself Save Old Smyrna was formed to oppose the wholesale demolition of the downtown, but this group never attracted widespread support.

The demolition of residential structures to make way for new and improved public facilities proved more controversial. Reconciling owners

to the loss of their homes was a difficult and protracted process. This was especially true in the case of Sunset Avenue, the street that ran through the site where the first components of the renewal project—a community center and new public library—were slated to be built.

Another goal of the mayor and council was to make these improvements without raising taxes. An increased tax rate, it was recognized, would discourage prospective new residents and businesses from moving into Smyrna. While the city had not increased its millage rate since 1958, the other basis on which real estate taxes were calculated, assessed valuations, were on the rise. The public required assurances that the contemplated improvements would not lead to a heavier tax burden. In championing potentially costly urban renewal for the downtown, the mayor and council assumed considerable political risk.

By the same token, municipal services had to be maintained and even improved if continued residential and commercial expansion was to take place. Former city councilman and state senator Hugh Ragan, who served on the council in the late 1980s, credited Smyrna's sustained rate of development in these years to

JULIA ROBERTS, 1967–

Smyrna's greatest celebrity, actress Julia Roberts, was born on October 28, 1967, in Atlanta, Georgia. Her parents, Walter Grady Roberts and Betty Lou Bredemus, were fourth-generation Atlantans. The Roberts family traced its Georgia roots back to great-grandfather John Pendleton Roberts, a farmer.

Julia's parents were theater people, the cofounders of the Atlanta Actors and Writers Workshop, located in Decatur, Georgia. Interestingly, this school was attended by the children of Reverend Martin Luther King Jr. The King and Roberts families were apparently close, and Coretta Scott King is reputed to have paid the hospital bill when Julia's mother gave birth to her.

Unfortunately, Julia's parents divorced when she was five years old, and her mother took Julia and older sister Lisa to live on Maner Street in the southern part of Smyrna. Older brother Eric, eleven years Julia's senior, was about to enter acting school and thus never resided in Smyrna.

Julia attended the Fitzhugh Lee Elementary School, the Griffin Middle School and, in 1985, graduated from Campbell High School (when it was housed in the building that now accommodates the Campbell Middle School).

Julia's father died of cancer in 1977. Her mother had meanwhile married Michael Motes of Smyrna, and they had a daughter, Julia's half-sister, Nancy Motes, in 1976.

Julia did not at first aspire to a career in acting. Her ambition as a high school student was to become a veterinarian. She played a clarinet in the Campbell High School

orchestra. Campbell High School offered little instruction in the arts, as Mrs. Motes recounted in an interview in 1994. "There was no chorus. The high school didn't even have junior-senior plays when they were growing up. I felt they were missing part of their education. But now Campbell has a chorus as well as a drama department," she declared. She went on to note that Julia was a little amused to learn that "Campbell now has an auditorium and that a drama award has now been named for her."

In 1987, Julia left Smyrna for New York City, where she launched her highly successful career as an actress. The girl from "a little town in Georgia," as she put it when accepting an Academy Award for her outstanding performance in the film Erin Brockovich, is today one of Hollywood's most celebrated stars, earning as much as $20 million per film. Her older sister, Lisa Roberts Gillam, who also grew up in Smyrna, has also achieved notable success in the acting profession.

the combination of low taxes and a pro-business climate.

But the city also had to offer prospective residents efficient municipal services. In 1989, Mayor Bacon boasted that Smyrna was already providing its people with "the best services of any municipality in Cobb County" and committed the city to maintain and augment those services.

The spectacularly successful downtown renewal project that took shape in the decade of the 1990s, it should be emphasized, also enjoyed the active and enthusiastic backing of the members of the Smyrna City Council.

In a conversation with this writer, the mayor expressed particular appreciation to Councilman Charles "Pete" Wood, a banker, who served on the council continuously from 1989 to 2012, for his sage financial advice, which the mayor asserted helped the city avoid many financial pitfalls.

The relationship between the mayor and his council colleagues was generally collaborative. Other councilmen and councilwomen who served throughout the amazingly transformative decade of the 1990s included Charlene Capilouto, Wade Lnenicka, Ron Newcomb, Bill Scoggins and Jim Hawkins.

The idea of building a community center had been in the works for about five years before the project was finally launched. The city had also outgrown its public library, a modest facility dating from 1961. Several locations were considered before the centrally located Sunset Avenue site was chosen for both new structures. The $15 million project would be paid for by the sale of municipal bonds. A bond issue did not require a public referendum, and rather than risk the possibility of rejection by the voters, the mayor decided to move forward on the basis of council

approval only, trusting that once the new structures were in place, public opinion would favor the project.

The building of a modern city center on generous grounds—a complex of handsome buildings that included a large and well-equipped community center, a state-of-the-art public library, a park/arboretum, a new city hall and modern police and fire headquarters, as well as a variety of architecturally coordinated commercial and residential structures, all centrally located and handsomely landscaped—was a decade-long process and a triumph of city planning and creative financing. The new downtown, which arose in stages over a ten-year period, fundamentally altered Smyrna's image. What occurred in downtown Smyrna in the 1990s was more than urban renewal—it was a veritable urban heart transplant.

With the goal of avoiding criticism that the city was being run with insufficient public input, the Smyrna Downtown Development Authority was created in April 1989 to guide the renewal process. Initially, the authority, which operated under the chairmanship of the mayor, included a cadre of only seven individuals: former Ward 7 councilman Hubert Black; Councilman Jimmy Wilson; businessman C.F. Fouts, owner of an auto service station; bank executive Charles "Pete" Wood (who shortly thereafter joined the council); City Clerk Willouise Spivey; attorney E. Alton Curtis Jr.; and local dentist Dr. Jim Pitts. The size of the authority would gradually expand over the years to encompass a broader cross-section of citizens.

The design contract for the community center and library went to the distinguished Atlanta-based architectural firm of Sizemore-Floyd. The architecture of the new complex is best described as "Williamsburg" in style. The Sizemore-Floyd firm, in fact, designed all of the major buildings in Smyrna's new downtown, which lends the architectural ensemble a pleasing, Neoclassical architectural unity.

The first components, the handsome community center and public library buildings, were dedicated in early August 1991 in a ceremony that featured fireworks, music, hot air balloons, rides and speeches from a litany of local politicians.

The dedication of these new public facilities coincided with the 1991 election season in which candidates were vying for the first time for four-year terms.

The timing of the library and community center openings was, on its face, fortunate for Mayor Bacon, in that it offered tangible evidence of the rehabilitation that the city was undergoing, but in other respects, the political climate was unfavorable. Smyrna in 1991 had been experiencing a run of

This page: The Smyrna Community Center and the Smyrna Public Library, both designed by the Sizemore Floyd architectural firm, were dedicated in August 1991, marking the completion of the first phase of the downtown renewal project.

bad luck that included a failed attempt to close down a nude dance club (the Georgia Supreme Court forbade the closing on constitutional grounds) and the proposed and somewhat controversial city purchase and condemnation of the badly deteriorated Heritage Pointe Apartment Complex, as well as some minor scandals involving city employees.

The mayor's sole opponent in this 1991 election was a seventy-year-old widow named Lena Dene Lindsey, who criticized him for proceeding with the project in the absence of a public referendum. She also condemned Bacon for taking private property to make way for the new buildings. In addition, the challenger made an issue of the city's $800,000 purchase from the Fouts brothers, longtime supporters of both Arthur and Max Bacon, of a ten-acre property on Atlanta Road for a public works yard, charging that the city had overpaid for the land.

Mayor Bacon's allies did their best to discredit this nettlesome challenger. "A 70-year old woman doesn't know how to run a city," C.F. Fouts declared, a remark that probably alienated many of the city's female and senior voters.

Also, the laggard economy of the early 1990s had slowed Smyrna's rate of development, and the city had been obliged to borrow to pay off the first installment of its $15 million revenue bond (payable in twenty-three installments of more than $1 million apiece), again raising the specter of higher taxes.

The mayor met these criticisms with assurances that taxes would not be raised and with a promise that voter approval would be sought for the second stage of the renewal project.

Notwithstanding her age, her lack of political experience and her miniscule campaign chest of just $800, Mrs. Lindsey garnered 42 percent of the vote in the 1991 mayoral race. If a better-known and better-funded candidate had challenged the mayor in 1991, he might well have suffered defeat in that election, as he himself admitted to this writer. Never again, however, would Max Bacon be seriously challenged in a mayoral race.

Another politically sensitive issue of the time was Smyrna's rapidly rising population of illegal immigrants. The Platinum Triangle, with its many service industry jobs, was a magnet for immigrants, legal and illegal alike, many of whom took up residence in the plethora of apartments available in adjacent Smyrna. By the late 1980s, there were an estimated six thousand immigrants, mostly Hispanic, residing in the city, 80 percent of whom were said to be illegals.

In April 1994, the city took its second major step in the downtown renewal project by seeking voter approval for a $7.65 million bond issue for the construction of a new police station and jail. To the immense satisfaction of the mayor, the bond issue won approval by a huge margin— nearly four out of five voters favoring it. Thus, a handsome new police station/jail was added to the so-called Village Green complex, a building dedicated in 1997.

Smyrna's handsome new city hall, dedicated in September 1996, stands at the center of the complex of municipal buildings that redefined the image of Smyrna.

The next phase of Smyrna's downtown renewal—the building of new city hall/municipal courthouse—was accomplished, remarkably, at no cost to the city. Smyrna had purchased a 460-unit, badly deteriorated apartment complex, dating from 1970, from the U.S. Department of Housing and Urban Development (HUD)—Heritage Pointe—conspicuously located at the intersection of Cumberland Boulevard and Cobb Parkway. The purchase was made with the goal of both rehabilitating the deteriorating complex and reducing its density, as part of the effort to shift the balance of the city's housing toward owner-occupied dwellings.

The city more than recouped its investment in this property by almost immediately selling the complex to two developers—Thomas Enterprises of Dunwoody and Teague-Ausburn properties of Buckhead at cost—in exchange for a commitment to not only rehabilitate and significantly reduce the density of Heritage Pointe but also to contribute other elements to the downtown renewal project.

Twenty acres of the Heritage Pointe complex were immediately taken down for a shopping center, while 180 of its badly deteriorated units were extensively rehabilitated. In exchange for ownership of Heritage Pointe, Teague-Ausburn constructed sixty-five townhouses along the western edge of the new downtown (on Bank and Hamby Streets), while Thomas

Smyrna's state-of-the-art police station/jail, located just north of the community center, was dedicated in 1998.

Enterprises provided new retail space and nineteen thousand square feet of office space in what is now Market Village.

Thomas Enterprises and Teague Auburn also contributed the $3 million required for the construction of Smyrna's handsome and centrally located new city hall/municipal courthouse building, the jewel in the crown of the complex of new government buildings that Smyrna acquired in the 1990s. All of this was accomplished, it should be emphasized, without raising taxes.

The moratorium on the building of new apartment buildings, together with the city's proactive role in promoting the rehabilitation of existing apartment complexes, had the effect of fundamentally altering the balance of apartment units to owner-occupied dwellings from a ratio of 2:1 in the 1980s to a current and more desirable 1:1 ratio.

Also built in the 1990s was a $700,000 adult recreation and aquatics center for the city's senior citizens, situated at the western end of Church Street on a piece of land that had formerly housed a teen youth center.

The last major structure to be built in the new downtown, a new central fire station, opened in 1999 just north of the police station.

Chief among the many amenities the city provides its growing population today is an extensive system of parks and playgrounds, a system that it continues to improve and expand year by year. In 2005, a $22 million bond issue was approved by the city's voters for the enhancement of this outstanding park system.

Smyrna has earned many awards for its downtown redevelopment project, including the Georgia Municipal Association's Innovative Achievement Award in 1991 and the prestigious Urban Land Institute's Award of Excellence in 1997.

While the old downtown has disappeared, much of Smyrna's older architectural fabric has survived, most notably in the area around the Concord Covered Bridge, the old Mill Village and the ruins of the Concord Woolen Factory, now set in Heritage Park.

As part of the downtown redevelopment project, the city established the Smyrna Museum across Atlanta Road from Market Village in a building that replicates, in its external appearance, the 1907 Smyrna Depot (casually demolished back in 1957 at a time when there was scant concern for historic preservation). The Smyrna Historical & Genealogical Society, founded in 1985 under the leadership of Betty and Harold Smith, administers the museum.

In addition, the oldest part of Aunt Fanny's Cabin, the famous Campbell Road restaurant, was moved to a parcel adjacent to the museum, where it serves today as the city's official visitors center. The handsome Guernsey Jug, another former eating establishment and originally part of the Creatwood Dairy complex, has likewise been preserved, slightly repositioned, and now functions as a clubhouse for a local housing complex.

And most recently, the Taylor-Brawner House Foundation—under the leadership of Lillie Wood, Mike Terry and other preservation-minded citizens—raised $500,000 to rehabilitate the historic Taylor-Brawner House, while the city renovated the Greek Revival–style Brawner Sanitorium building, now known as Brawner Hall. This outstanding example of the adaptive reuse of a historic property provides office space for two city departments, training classrooms, conference rooms and a stately reception room. These properties sit, moreover, in a ten-acre park that features a gazebo, two picnic pavilions, a walking trail, an amphitheater, a playground and open space. These historic buildings were recently added to the National Register of Historic Places, among the first Smyrna properties to be so designated.

There are, in addition, many individual Smyrna properties that warrant a measure of historical and architectural attention. The Williams Park neighborhood, which lies directly across Atlanta Road from Market Village, contains a sizeable concentration of historic houses built between 1884 and the early 1920s that warrants consideration for National Register listing.

While the 2008 recession significantly slowed development in Smyrna, there are strong indications that the city's economy is rebounding. The Jonquil City—now one of Metropolitan Atlanta's premier suburbs—seems poised for additional quality development in the years ahead.

BIBLIOGRAPHY

Applebome, Peter. *Dixie Rising: How the South Is Shaping American Values, Politics, and Culture*. New York: Random House, 1996.

Ayers, Edward L. *The Promise of the New South: Life After Reconstruction*. 15th ed. Oxford, NY: Oxford University Press, 2007.

————. *What Caused the Civil War: Reflections on the South and Southern History*. New York: W.W. Norton, 2005.

Bacon, Benjamin W. *Sinews of War: How Technology, Industry, and Transportation Won the Civil War*. Novato, CA: Presidio Press, 1997.

Baylor, Ronald H. *Race and the Shaping of Twentieth Century Atlanta*. Chapel Hill: University of North Carolina Press, 1996.

Blackmon, Douglas M. *Slavery by Another Name: The Re-Enslavement of Black Americans from the Civil War to World War II*. New York: Anchor Books, 2008.

Boritt, Gabor S., ed. *Why the Confederacy Lost*. New York: Oxford University Press, 1992.

But Thou Art Rich: A History of Methodists in Smyrna (Cobb County) Georgia, 1990. Columbus, GA: Quill Publications, 1990.

Cimballa, Paul A. *Under the Guardianship of the Nation: The Freedman's Bureau and the Reconstruction of Georgia, 1865–1870*. Athens: University of Georgia Press, 1997.

Cobb, James C. *Away Down South: A History of Southern Identity*. Oxford, NY: Oxford University Press, 2005.

———. *Georgia Odyssey: A Short History of the State*. 2nd ed. Athens: University of Georgia Press, 2008.

Coffman, Richard M. *Going Back the Way They Came: A History of the Phillips Georgia Legion Cavalry Battalion*. Macon, GA: Mercer University Press, 2011.

Coffman, Richard M., and Kurt D. Graham. *To Honor These Men: A History of the Phillips Georgia Legion Infantry Battalion*. Macon, GA: Mercer University Press, 2007.

Coker, Joe L. *Liquor in the Land of the Lost Cause: Southern White Evangelicals and the Prohibition Movement*. Lexington: University Press of Kentucky, 2007.

Davis, Robert Scott. *Civil War Atlanta*. Charleston, SC: The History Press, 2011.

Davis, Stephen. *Atlanta Will Fall: Sherman, Joe Johnston, and the Yankee Heavy Battalions*. Wilmington, DE: Scholarly Resources Inc., 2001.

Dosser, David A., Sr. *Let Justice Be Done: The Life and Times of Justice J. Harold Hawkins*. N.p.: self-published, n.d.

Dow, Neal. *The Reminiscences of Neal Dow: Recollections of Eighty Years*. Portland, ME: Evening Express Publishing Company, 1898.

Downing, David C. *A South Divided: Portraits of Dissent in the Confederacy*. Nashville, TN: Cumberland House Publishing, 2007.

Doyle, Anthony. *Standing Peachtree Revisited: A Cold Case of Native Provenance*. N.p.: self-published, 2011.

Duncan, Russell. *Entrepreneur for Equality: Governor Rufus Bullock, Commerce, and Race in Post Civil War Georgia*. Athens: University of Georgia Press, 1994.

Ecelbarger, Gary. *The Day Dixie Died: The Battle of Atlanta*. New York: St. Martin's Press, 2010.

Escott, Paul D. *After Secession: Jefferson Davis and the Failure of Confederate Nationalism*. Baton Rouge: Louisiana State University Press, 1978.

Evans, David. *Sherman's Horsemen: Union Cavalry Operations in the Atlanta Campaign*. 2nd ed. Bloomngton: Indiana University Press, 1999.

Fahey, David. *Temperance and Racism: John Bull, Johnny Reb, and the Good Templars*. Lexington: University Press of Kentucky, 1996.

Fellman, Michael. *Citizen Sherman: A Life of William Tecumseh Sherman*. New York: Random House, 1995.

Freehling, William W., and Craig M. Simpson, eds. *Secession Debated: Georgia's Showdown in 1860*. New York: Oxford University Press, 1992.

Georgia Department of Agriculture. *Georgia: Historical and Industrial*. Atlanta, GA: self-published, 1911.

Glover, James Bolan. *Images of America: Marietta, 1833–2000*. Charleston, SC: Arcadia Publishing, 2000.

Hahn, Steven. *A Nation Under Our Feet: Black Political Struggles in the Rural South from Slavery to the Great Migration*. Cambridge, MA: Belknap Press, 2005.

Holmes, Michael S. *The New Deal in Georgia: An Administrative History*. Westport, CT: Greenwood Press, 1975.

Isanhour, Clare. *Hardy Pace Family: Pioneers of Vinings in Georgia*. Vinings, GA: Vinings Historic Preservation Society, 2010.

Johnston, Joseph E. *Narrative of Military Operations during the Civil War*. Cambridge, MA: DaCapo Press, 1959.

Joiner, Oscar, ed. *A History of Public Education in Georgia, 1734–1976*. Columbia, SC: R.L. Bryan Company, 1979.

Kendall, Susan. *Images of America: Vinings*. Charleston, SC: Arcadia Publishing, 2013.

King, William. *Diary of William King, Cobb County, Georgia, 1864*. N.p., n.d.

Kirby, Joe. *Images of America: The Bell Bomber Plant*. Charleston, SC: Arcadia Publishing, 2008.

———. *Images of America: The Lockheed Plant*. Charleston, SC: Arcadia Publishing, 2011.

Kirby, Joe, and Damien A. Guarnieri. *Marietta: Then & Now*. Charleston, SC: Arcadia Publishing, 2007.

Kruse, Kevin M. *White Flight: Atlanta and the Making of Modern Conservatism*. Princeton, NJ: Princeton University Press, 2005.

Longacre, Edward G. *Worthy Opponents: William T. Sherman and Joseph E. Johnston: Antagonists in War, Friends in Peace*. Nashville, TN: Rutledge Hill Press, 2006.

Lowry, Amy Gillis, and Abbie Tucker Parks. *Images of America: North Georgia's Dixie Highway*. Charleston, SC: Arcadia Publishing, 2007.

MacLean, Nancy. *Behind the Mask of Chivalry: The Making of the Second Ku Klux Klan*. Oxford, NY: Oxford University Press, 1994.

McDonough, James Lee, and James Pickett Jones. *War So Terrible: Sherman and Atlanta*. New York: W.W. Norton & Company, 1987.

McFeely, William S. *Yankee Stepfather: General O.O. Howard and the Freedmen*. New York: W.W. Norton, 1994.

Miles, Jim. *Fields of Glory: A History and Tour Guide of the Atlanta Campaign*. Nashville, TN: Rutledge Hill Press, 1989.

Mohr, Clarence L. *On the Threshold of Freedom: Masters and Slaves in Civil War Georgia*. Athens: University of Georgia Press, 1986.

Moran, Martin. *Tincture of Time: The Story of 150 years of Medicine in Atlanta, 1845–1995*. Atlanta, GA: Williams Printing, 1995.

Northen, William J. *Men of Mark in Georgia: A Complete and Elaborate History of the State From Its Settlement to the Present Time, Chiefly Told in Biographies and Autobiographies*. Atlanta, GA: A.B. Caldwell, 1910.

Oney, Steve. *And the Dead Shall Rise: The Murder of Mary Phagan and the Lynching of Leo Frank*. New York: Vintage Books, 2003.

Pope, Mark Cooper Pope, III. *Mark Anthony Cooper: The Iron Man of Georgia*. Atlanta, GA: Graphic Publishing Company, 2000.

Powell, Thomas. *The Persistence of Racism in America*. Lanham, MD: Littlefield Adams Quality Paperbacks, 1993.

Raab, James W. *Deliverance from Evil: General Francis Asbury Shoup, C.S.A.* West Conshohocken, PA: Infinity Publishing, 2012.

Rose, Michael. *Atlanta: A Portrait of the Civil War*. Charleston, SC: Arcadia Publishing, 1999.

Scaife, William R. *The Campaign for Atlanta*. Atlanta, GA: self-published, 1993.

Scott, Thomas Allan. *Cobb County, Georgia, and the Origins of the Suburban South: A Twentieth Century History*. Marietta, GA: Cobb Landmarks and Historical Society, 2003.

Sherman, William Tecumseh. *Memoirs of General W.T. Sherman*. New York: Penguin Books, 2000.

Smith, Harold. *A Beacon for Christ: A Centennial History of the First Baptist Church of Smyrna, Georgia*. Smyrna: First Baptist Church of Smyrna, Georgia, 1984.

———. *Historic Smyrna: An Illustrated History*. San Antonio, TX: Historic Publishing Network, 2010.

Symonds, Craig L. *Joseph E. Johnston: A Civil War Biography*. New York: W.W. Norton, 1994.

Temple, Sarah Blackwell Gober. *The First Hundred Years: A Short History of Cobb County in Georgia*. 5th ed. Atlanta, GA: Cherokee Publishing Company, 1980.

Terry, Michael. *A Simpler Time: The Story of the Taylor-Brawner House and the Brawner Hospital*. Madison, GA: Southern Lion Books, 2012.

Wood, Charles "Pete." *The Paper Boy: A Collection of Memories from the Middle of the Twentieth Century in Smyrna, Georgia*. Smyrna, GA: self-published, 2006.

Wood, Richard G. *Stephen Harriman Long, 1784–1864: Army Engineer, Explorer, Inventor*. Glendale, CA: Arthur H. Clark Company, 1966.

INDEX

water supply 75, 91
Western & Atlantic Railroad 29, 32,
 35, 50
Whitfield, Thomas P. 79, 81
Wight, Edward 94
Wikle Drug Company racial incident
 100
William Ireland Homestead 59
Williams Park 124, 146
Wills, Francis T. 94, 101
Wooten, J.Y. 115
Works Progress Administration 93, 109

Z

zoning 92, 123, 130

ABOUT THE AUTHOR

William P. Marchione is a retired history professor, author, lecturer and oral historian. He holds degrees in history from Boston University (BA, 1964), George Washington University (MA, 1969) and Boston College (PhD, 1994). In the mid-1970s, he did extensive graduate work on the history of the South at the University of Tennessee. Articles by Marchione have appeared in the *New England Quarterly* and the *South Carolina Historical Magazine*. A former longtime member of the Boston Landmarks Commission, Dr. Marchione has received numerous awards and citations for his work as a local historian, educator, preservationist and lecturer. *A Brief History of Smyrna, Georgia* is his seventh book and his third for The History Press.

Visit us at
www.historypress.net
..
This title is also available as an e-book